The Frick Collection

DECORATIVE ARTS HANDBOOK

The Frick Collection

DECORATIVE ARTS HANDBOOK

Charlotte Vignon

THE FRICK COLLECTION, NEW YORK,
IN ASSOCIATION WITH SCALA ARTS PUBLISHERS, INC.

Published in association with
Scala Arts Publishers, Inc., New York,
by The Frick Collection:
Michaelyn Mitchell, Editor in Chief
Hilary Becker, Assistant Editor

The Frick Collection
1 East 70th Street
New York, NY 10021
www.frick.org

Scala Arts Publishers, Inc.
141 Wooster Street, Suite 4D
New York, NY 10012

Designed by Jo Ellen Ackerman
Printed in China

Front cover: *Potpourri Vase "á Vaisseau"*
(p. 120)
Back cover: Detail of *Oval Dish: The Last
Supper; Jupiter* (p. 28)
Back flap: *Two Figures of Ladies on
Stands* (p. 132)
Pages ii–iii: Detail of *Side Table* (p. 102)
Page v: Detail of *Console Table* (p. 97)
Page vi: The Fragonard Room at The
Frick Collection
Pages x–1: Detail of *The Triumph of the
Eucharist and the Catholic Faith* (p. 18)
Pages 40–41: Detail of *Double-Dial Watch*
(p. 67)
Pages 70–71: Detail of *Secretaire* (p. 98)
Pages 106–7: Detail of *Side Table* (p. 102)
Pages 114–15: Detail of *Vase Japon* (p. 124)
Pages 126–27: Detail of *Two Figures of
Ladies on Stands* (p. 132)
Pages 134–35: Detail of *Wine Cooler* (p. 138)
Pages 140–41: Detail of *Arrival of the
Shepherdesses at the Wedding of Camacho*
(p. 148)

10 9 8 7 6 5 4 3 2 1

Library of Congress Cataloging-in-
Publication Data
Frick Collection.
 The Frick Collection : decorative arts
handbook / Charlotte Vignon.
 pages cm
 ISBN 978-1-85759-939-8 (alk. paper)
 1. Decorative arts--Catalogs. 2.
Decorative arts--New York (State)--
New York--Catalogs. 3. Frick
Collection--Catalogs. I. Vignon,
Charlotte, author. II. Title.
 NK460.N4F754 2015
 745.074'7471--dc23
 2014039206
ISBN: 978-1-85759-939-8

All photographs are by Michael
Bodycomb with the exception of the
comparative illustrations on pages 3,
8, 11, 117, and 124.

NOTE TO THE READER
This handbook is organized chrono-
logically and by medium, beginning
with sixteenth-century enamels and
ending with eighteenth-century
tapestries. Within each section, the
works are organized chronologically,
but artists and workshops are
presented together.

ACKNOWLEDGMENTS
This handbook is indebted to *The Frick
Collection: An Illustrated Catalogue*
(1974–1992), and I wish to acknowledge
the esteemed scholars responsible for
the four volumes dedicated to the
decorative arts: Marcelle Brunet,
Kathryn C. Buhler, Theodore Dell,
Maurice S. Dimand, David Dubon, John
A. Pope, and Philippe Verdier. More
recently, the Winthrop Kellogg Edey
bequest of clocks and watches was
studied and catalogued by William
Andrewes. Even more recently, in
2014, the collection of blue-and-white
Chinese porcelain bequeathed to the
museum by Childs Frick was studied
by Kaijun Chen and Amy G. Poster.
New attributions, datings, and a better
understanding of these objects have
been made possible thanks to a
wonderful collaboration with the Frick's
Conservation Department. I wish to
extend my sincere gratitude to Adrian
Anderson, Julia Day, Brittany Luberda,
Patrick King, and the head of the
department, Joseph Godla. My deep
appreciation goes to Ian Wardropper
and Xavier F. Salomon for their
unfailing support. While many Frick
staff members have been involved with
this project, I would like to particularly
single out Michaelyn Mitchell and
Hilary Becker for their careful editing
and supervision of the publication, and
Michael Bodycomb for his splendid
photographs. I also thank Martina
d'Amato and Sarah Brown-McLeod,
then students at the Bard Graduate
Center, for their assistance during the
summer and fall of 2011. Finally, this
project would have not been possible
without the initiative and support of
former staff members Anne L. Poulet,
Colin B. Bailey, and Elaine Koss.

Contents

vii Director's Foreword

1 Enamels

41 Clocks and Watches

71 Furniture

107 Gilt Bronzes

115 European Ceramics

127 Chinese Porcelain

135 Silver

141 Textiles

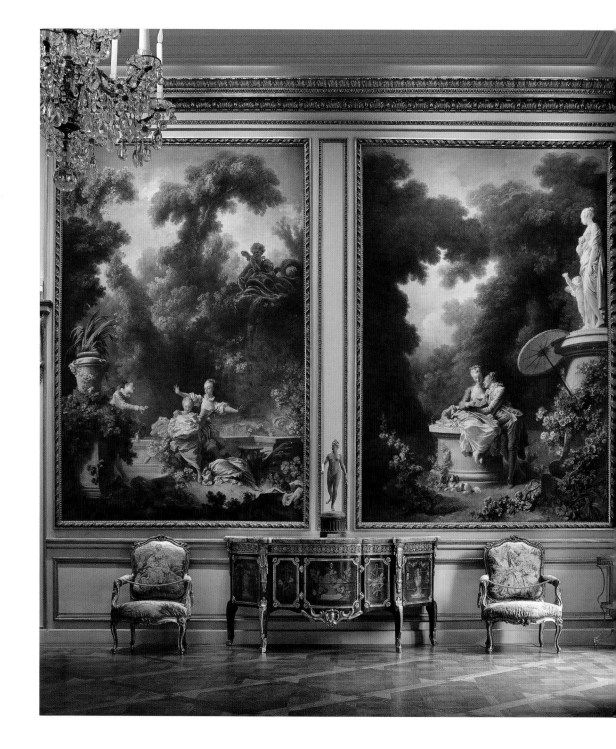

Director's Foreword

The unique atmosphere of The Frick Collection has as much to do with the decorative arts as with the old master paintings that line our walls. Indeed the enamels, clocks and watches, furniture, gilt bronzes, porcelain, ceramics, silver, and textiles far exceed in number, and are the equal in quality of, the works on canvas and panel. Long overdue, this handbook—the first devoted to the decorative arts in our collection—will help convey the balance among the various art forms represented at the Frick and provide a valuable introduction to this area.

Acquiring paintings had preoccupied Henry Clay Frick many years before he moved to New York in the first years of the twentieth century. While renting William H. Vanderbilt's mansion at Fifth Avenue and 51st Street, he devoted his attention to collecting masterpieces by Rembrandt, Velázquez, and other masters, but as the sumptuous house he was building on 70th Street took shape between 1912 and 1914, he recognized the need for furnishings of a caliber that matched his painting collection. Interestingly, most of his purchases in this area were made just before or after he began to occupy the house and in a very concentrated period of time.

A trip to London and Paris in the spring of 1914 inspired many of the choices Frick would make for his New York mansion. After meeting Victor Cavendish, ninth Duke of Devonshire, at Landsdowne House in London and his country house at Chatsworth, Frick acquired from him a suite of tapestry furniture thought to be eighteenth-century Gobelins. Impressed by the Wallace Collection and wishing to emulate it, he set out to acquire high-quality decorative arts of different periods and materials,

especially porcelain, oriental carpets, and French Renaissance enamels and furniture, such as pieces made by André-Charles Boulle, with their distinctive turtle-shell and brass veneers. In Paris, through the intermediary of the American decorator Elsie de Wolfe, he purchased French furniture from the collection of Sir John Murray Scott (inherited from Lady Wallace, the widow of the founder of the Wallace Collection). In a single month, he spent more than $400,000, more than he had ever spent on collecting in this field.

In some cases, furniture and decorative arts were assembled to complement specific rooms of the house. Elsie de Wolf, for example, counseled the acquisition of a desk by the great French eighteenth-century cabinetmaker Jean-Henri Riesener together with Sèvres porcelain for Adelaide Frick's second-floor dressing room, which was lined with wall panels painted by François Boucher's workshop. The room and its furnishings were transferred to the first floor in 1935 to be accessible to the museum's visitors. Other great eighteenth-century French furnishings for Adelaide's dressing room came through Joseph Duveen, then the head of Duveen Brothers. After Fragonard's cycle of paintings was installed in the drawing room in 1915–16, Duveen sold Frick many more works to embellish the decor of the room. French Renaissance furniture was bought to complement the collection of sixteenth-century enamels acquired in 1916; Henry's office was transformed into a gallery for its display. The Italian Renaissance cassoni were always intended to be placed beneath masterpieces of painting in the West Gallery.

Carefully selected blocs of decorative arts, such as the forty-six pieces of Limoges enamel Frick acquired through Duveen from the estate of J. Pierpont Morgan, were one means by which the collection grew quickly. Morgan's death in 1913 gave Frick the opportunity to choose from one of the finest and largest collections in the world just when he was seeking to expand in this area. Another example was the group of fifty Chinese porcelain jars and vases that Duveen had also acquired from Morgan's estate. Apart from the windfall of the availability of the Morgan collection, Duveen's own stock was so extensive and of such quality that Frick

could buy from him French royal commissions, such as Gilles Joubert's commode, which was among some twenty-five pieces of furniture that arrived at Fifth Avenue and 70th Street during the year 1915.

Generous gifts from members of the Frick family and other donors have continued to enrich the decorative arts collection. The founder's son, Childs, gave more than two hundred pieces of blue-and-white porcelain in 1965, considerably augmenting the works his father had purchased fifty years earlier. In 1999, Winthrop Kellogg Edey's extraordinary collection of some forty clocks and watches arrived at the Frick. Henry Arnhold has recently given us the *Great Bustard* from his distinguished and comprehensive collection of Meissen porcelain, and another one hundred and thirty-five works are pledged to the Frick as a bequest. Individual objects of great merit are prized additions to our holdings. Diane Modestini gave the first piece of Italian maiolica in honor of her husband, Mario Modestini, in 2008. On occasion, acquisitions are also made, such as the unusual *vase japon,* purchased in 2011.

Despite the manifest importance of decorative arts at the Frick, until recently our small staff did not include a specialist in the field. Thanks to an endowment campaign and the generosity of a number of supporters, a permanent curatorial position was created in September 2009. With energy and imagination, the first incumbent of this curatorship, Charlotte Vignon, has initiated a series of exhibitions that highlight this aspect of the collection. The present handbook is another indication of her dedication to and research on the decorative arts. Technical studies conducted by Conservators Joseph Godla and Julia Day have established a significant basis for the art historical text. Our talented photographer Michael Bodycomb captured all the nuances of these beautiful objects while Michaelyn Mitchell and Hilary Becker carefully attended to the editing and production of this volume.

Ian Wardropper
Director, The Frick Collection

Enamels

Triptych: The Crucifixion with St. Barbara and St. Catherine of Alexandria

MASTER OF THE ORLÉANS TRIPTYCH
French, Limoges, ca. 1500
Painted enamel on copper, partly gilded
Central plaque: 8 × 6⅜ in. (20.3 × 16.2 cm)
Wings: 8⅛ × 2⅝ in. (20.6 × 6.7 cm)
Henry Clay Frick Bequest (1918.4.01)

The earliest painted enamels from Limoges reflect the influence of books of hours and other medieval illuminated manuscripts. The Crucifixion scene shown here derives from a book of hours (now in the Art Institute of Chicago) that belonged to Katherine Gentille, wife of Marsau Dubost, consul of Limoges, in 1510. The triptych bears stylistic and technical similarities to approximately twenty-five enamels in public and private collections in Europe and the United States. As none of these are signed or dated, the enameler became known as the Master of the Orléans Triptych or the Master of the Baltimore and Orléans Triptychs, in reference to two of his works in the Musée des Beaux-Arts d'Orléans and the Walters Art Museum, respectively.

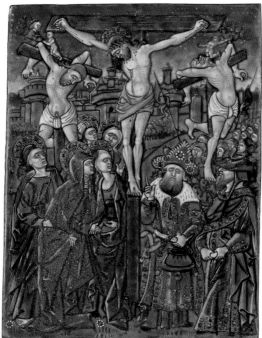

The Adoration of the Magi

**WORKSHOP OF THE MASTER OF THE
LARGE FOREHEADS**

French, Limoges, ca. 1510
Painted enamel on copper, partly gilded
10¼ × 9⅛ in. (26 × 23.2 cm)
Henry Clay Frick Bequest (1916.4.04)

This composition is adapted from an Adoration of the Magi enameled twice by the Master of the Orléans Triptych, under whom the Master of the Large Foreheads probably worked before establishing his own workshop. Slanted eyes, puffy eyelids, and high, rounded foreheads characterize his production. The composition borrows many details from a print of around 1480–85 by the Netherlandish Master IAM, in which the main scene is set before ruins that evoke Solomon's Temple, said to have been destroyed when Christ was born.

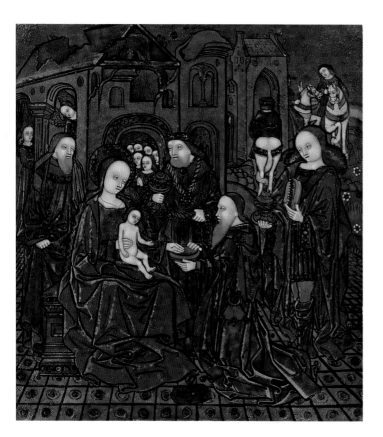

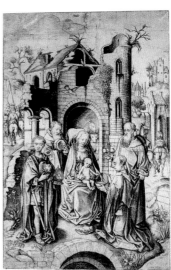

Master IAM of Zwolle, *The Adoration of the Magi*, ca. 1470–95. Engraving, 13⅞ × 9⅜ in. (35.1 × 23.9 cm). The British Museum (1845,0809.228). © Trustees of The British Museum

*Triptych: The Crucifixion with The Way to
Calvary and The Deposition*

WORKSHOP OF THE MASTER OF THE LARGE
FOREHEADS
French, Limoges, ca. 1510
Painted enamel on copper, partly gilded
Central plaque: 9¼ × 8⅛ in. (23.5 × 20.6 cm)
Wings: 9¼ × 3½ in. (23.4 × 8.9 cm)
Henry Clay Frick Bequest (1916.4.05)

Enamelers in the workshops in Limoges are known
to have copied each other's compositions and also
to have worked together. For example, the three
crosses, the view of Jerusalem, and the detachment
of soldiers in the central panel are seen, with only
slight variations, in several enamels by the Master
of the Orléans Triptych, including *The Crucifixion*
in The Frick Collection (p. 2). The body of Christ
closely follows a composition by Nardon Pénicaud,
who had himself adapted a scene by the Master
of the Orléans Triptych. Also typical of the period
is the extensive use of cabochons, recalling the
work of contemporary silversmiths. Such "gems"
were created by applying raised drops of colored
translucent enamels over small pieces of silver foil.

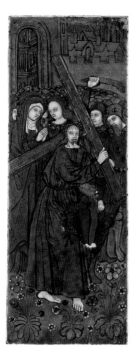
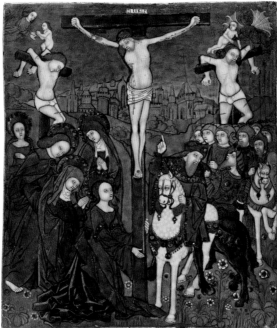
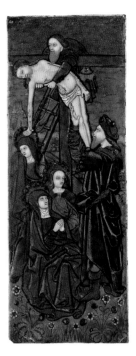

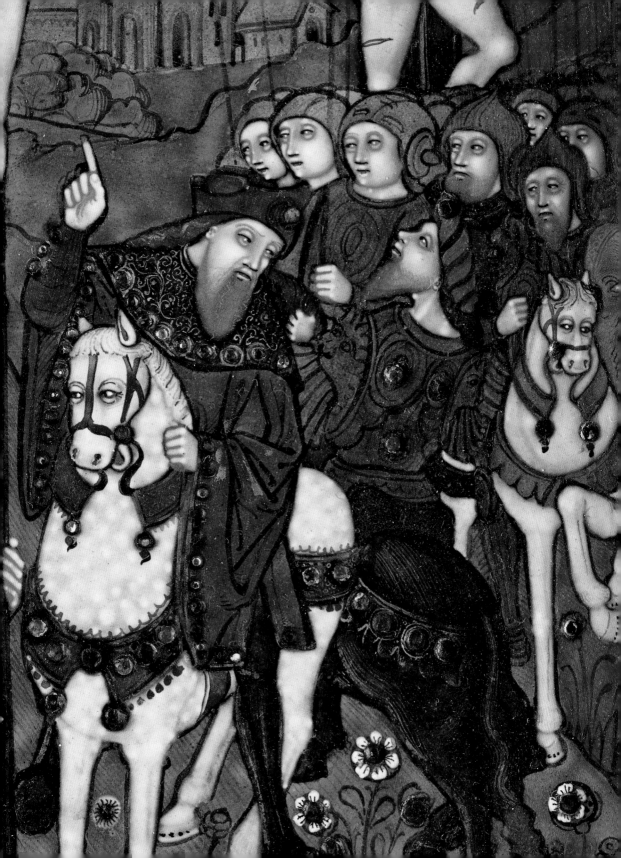

Triptych: The Death of the Virgin with
The Assumption and The Coronation

WORKSHOP OF NARDON PÉNICAUD
French, Limoges, ca. 1520–25
Painted enamel on copper, partly gilded
Central plaque: 9⅛ × 7½ in. (23.2 × 19.1 cm)
Wings: 9⅛ × 3¼ in. (23.2 × 8.3 cm)
Henry Clay Frick Bequest (1916.4.02)

Nardon Pénicaud (act. 1493–1539) was the patriarch of one of the most prominent families of enamelers in Limoges. Inspired by late Gothic and early Renaissance styles, his work is characterized by monumental figures set in somber compositions. While the composition of the central panel, depicting the death of the Virgin, had already appeared in an enamel made in the workshop of the Master of the Orléans Triptych, the scene at the left appears to be unique. Arriving too late to witness the Assumption of the Virgin, St. Thomas doubted her ascent until he received her sash from an angel. The Coronation, at right, derives from contemporary printed books of hours.

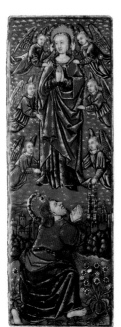
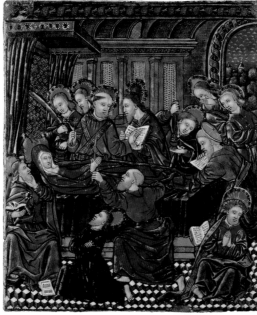
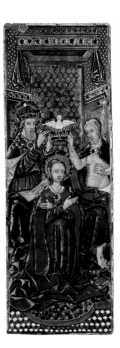

Triptych: The Crucifixion with The Way to
Calvary and The Deposition

WORKSHOP OF NARDON PÉNICAUD OR
JEAN PÉNICAUD I

French, Limoges, ca. 1520–25

Painted enamel on copper, partly gilded

Central plaque: 10³⁄₁₆ × 9½ in. (25.9 × 24.1 cm)

Wings: 10½ × 3¾ in. (26.7 × 9.5 cm)

Henry Clay Frick Bequest (1918.4.08)

The central panel copies a Crucifixion printed in a book of hours first published in 1505 by Thielmann Kerver, a German bookseller established in Paris. The same scene appears in a triptych by Nardon Pénicaud, from around 1520–25 (now in the Walters Art Gallery), that is flanked by plaques very similar to *The Way to Calvary* and *The Deposition.* Another close version is in the Louvre Museum. It is difficult to attribute this triptych to either the workshop of Nardon Pénicaud or the one run by his younger brother, Jean Pénicaud I, as they used the same iconographic sources and techniques and probably worked together for several years.

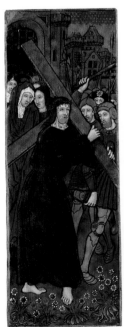
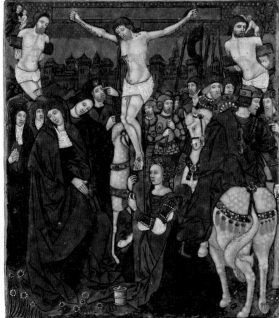
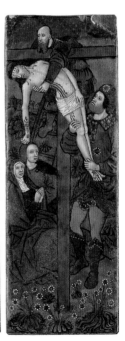

Double-Tiered Triptych: Scenes from the Passion of Christ

WORKSHOP OF NARDON PÉNICAUD
French, Limoges, mid-sixteenth century
Painted enamel on copper, partly gilded
Upper central plaque: 5½ × 11 in. (14 × 28 cm)
Upper wings: 5¾ × 4¾ in. (14.6 × 12 cm)
Lower central plaque: 9⅞ × 11⅜ in. (25.1 × 28.9 cm)
Lower wings: 9¾ × 5 in. (24.8 × 12.7 cm)
Henry Clay Frick Bequest (1916.4.03)

Although signed NARDON PÉNICAUD, this triptych was probably produced by a younger member of Pénicaud's workshop, possibly after his death in 1541. The individual scenes derive in part from a series of engravings of the Passion of Christ by the German engraver and painter Martin Schongauer (ca. 1445–1491). The complex iconographic program starts with the plaque at the upper left that depicts Christ bearing the cross and returning to Veronica the veil she had offered him earlier, which now features an impression of his face. The Crucifixion is at the upper center, the Deposition at the lower left, and the Entombment in the lower central plaque. On the upper right, Christ's victory over death is depicted in the triumphant Harrowing of Hell, followed by the Resurrection at the lower right. The triptych's brilliance is achieved by the extensive use of silver foil beneath the translucent colored enamel.

Monogrammist BG after Martin Schongauer, *Christ Carrying the Cross,* ca. 1470–90. Engraving, 6⅜ × 4⅜ in. (16.1 × 11.1 cm). The British Museum (E,1.208). © Trustees of The British Museum

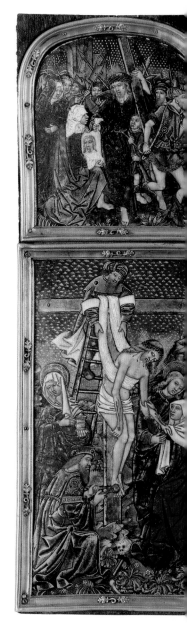

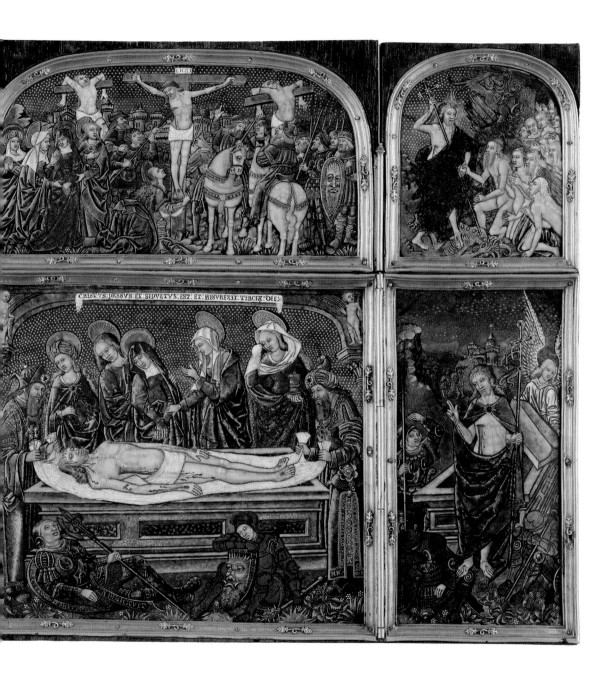

9

The Agony in the Garden

JEAN PÉNICAUD I

French, Limoges, ca. 1520–25

Painted enamel on copper, partly gilded

10⅞ × 9½ in. (27.6 × 24.1 cm)

Henry Clay Frick Bequest (1916.4.06)

Until the 1920s, the signature of Jean Pénicaud I was visible on the white rock in the foreground, where the initials IP, linked together by a small cord, were written in gold. Today, there remain only a few isolated dots and faint indications of the loops of the cord. This plaque, which belongs to a group of eight enamels that depict episodes in Christ's life and are signed by Jean Pénicaud I, is very similar to one depicting the Way to Calvary (now in the British Museum); both may have once been part of a polyptych illustrating the Passion of Christ. For the composition, Pénicaud relied primarily on *The Agony in the Garden*, engraved around 1480 by Martin Schongauer.

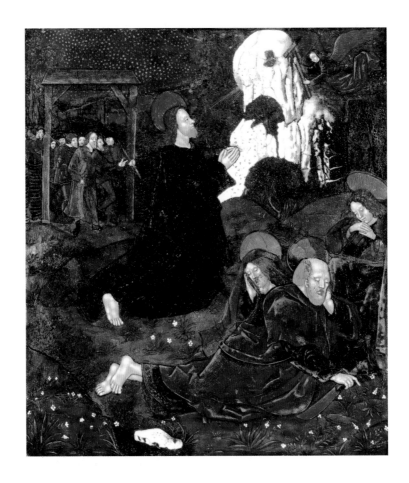

Triptych: Christ Crowned with Thorns
with The Kiss of Judas and The Flagellation

JEAN PÉNICAUD I

French, Limoges, ca. 1525–35

Painted enamel on copper, partly gilded

Central plaque: 10⅝ × 9⅜ in. (27 × 23.8 cm)

Wings: 10⅝ × 4²⁄₁₆ in. (27 × 10.6 cm)

Henry Clay Frick Bequest (1916.4.07)

This triptych is not signed, but the technique, broad drawing style, and high-keyed palette are consistent with works by Jean Pénicaud I. Like many enamelers before and after him, Pénicaud drew elements of his compositions from prints that were circulating throughout Europe and provided exposure to international artistic currents. For the central scene, he closely followed an engraving by Martin Schongauer, enlarging the figures to allow their dynamic poses, demonstrative gestures, and brightly colored garments to fill the space. He also included Italian elements that would have been perceived as modern motifs in early sixteenth-century France: the geometric tile floor, the marble insets in the back wall, and the classical columns.

Martin Schongauer, *Christ Crowned with Thorns*, 1470–82. Engraving, 6⅛ × 4½ in. (16.1 × 11.5 cm). The British Museum (1895,0915.244). © Trustees of The British Museum

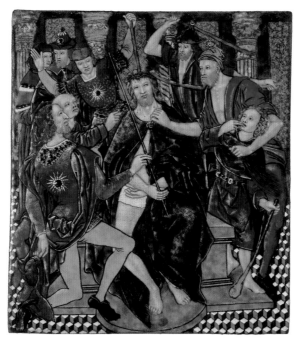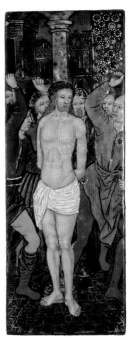

Triptych: The Crucifixion
with The Way to Calvary and The Pietà

ATTRIBUTED TO JEAN PÉNICAUD I OR
THE MASTER OF THE LOUIS XII TRIPTYCH
French, Limoges, ca. 1525–35
Painted enamel on copper, partly gilded
Central plaque: 10³⁄₁₆ × 8¾ in. (25.9 × 22.2 cm)
Wings: 10¼ × 3¾ in. (26 × 9.5 cm)
Henry Clay Frick Bequest (1918.4.09)

As per common practice in early sixteenth-century enameling, the artist uses a variety of techniques to convey emotion and realism. For example, to accentuate the lifeless bodies of Christ and the thieves, he uses *enlevage*, the technique of scraping away layers of white enamel to reveal the dark ground underneath. This effect is enhanced by the pink wash added to the cheeks of the surrounding figures, contrasting their flush with the gray pallor of Christ and the thieves. Their gaunt appearance is also painstakingly rendered, and in both *The Crucifixion* and *The Pietà*, tears are visible in the eyes of the mourning women and St. John. Traditionally attributed to Jean Pénicaud I, this triptych could be the work of the enameler known as the Master of the Louis XII Triptych (after the triptych now at the Victoria and Albert Museum) because of the unusual blue-gray enamel on the reverse side of the plaque.

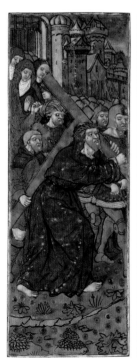 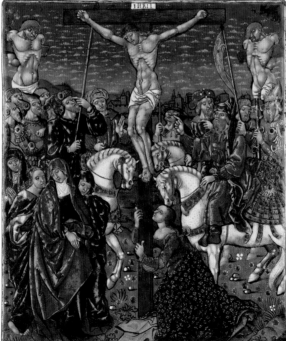 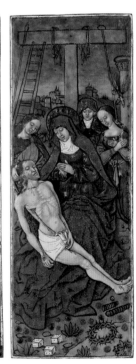

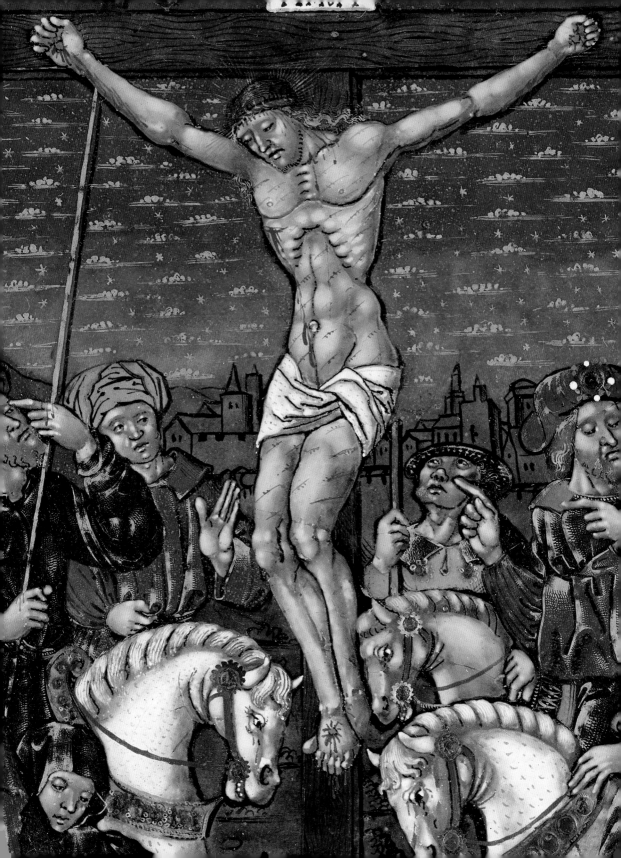

Martyrdom of a Saint

ATTRIBUTED TO JEAN PÉNICAUD I

French, Limoges, ca. 1525–35

Painted enamel on copper, partly gilded

6½ × 6⅛ in. (16.5 × 15.6 cm)

Henry Clay Frick Bequest (1916.4.10)

The man being tortured might be the Apostle St. James the Less, first Bishop of Jerusalem. According to tradition, the scribes and Pharisees asked that James the Less be thrown from the pinnacle of the temple and then clubbed to death. The frieze of cherub heads across the top of the wall might refer to the temple, known for its effigies of cherubim, while the background figures could represent the scribes and Pharisees. The word MALCO on the green skirt of a tormentor on the right could be an allusion to Malchus, the servant of the high priest of Jerusalem. The inscription continues on the purple skirt of the tormentor next to him: GANEL . . . This is a possible reference to Ganelon, the traitor in *La Chanson de Roland*.

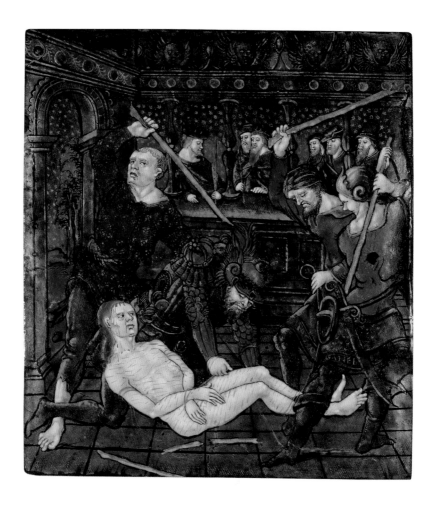

Casket: Putti and Mottoes of Courtly Love

ATTRIBUTED TO COLIN NOUAILHER
French, Limoges, ca. 1545
Painted enamel on copper, partly gilded
4¾ × 7¼ × 4¾ in. (12 × 18.4 × 12.1 cm)
Henry Clay Frick Bequest (1916.4.14)

In the mid-sixteenth century, enamelers increasingly produced three-dimensional objects decorated with secular scenes. This small casket is composed of thirteen plaques that depict naked putti playing musical instruments, engaging in mock battles, and courting young girls. Each scene is accompanied by phrases in old French on love's joys and cruelties, for example, AMOVR.DONE.IOYE (Love gives joy) and PAR AMOR VAINCV (Defeated by love). Such messages were often inscribed on love tokens and nuptial gifts, and this casket may have served a similar purpose. The front plaque at the lower left even depicts a putto presenting his beloved with a casket, along with the words LE PRINS DE BONE FOY (Take it in good faith).

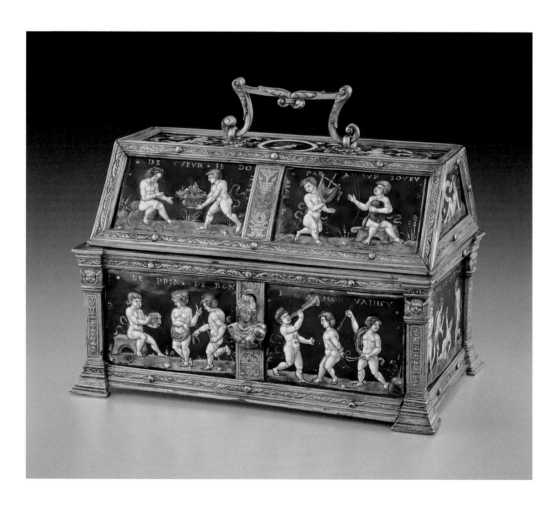

Portrait of a Bearded Man (Guillaume Farel?)

LÉONARD LIMOUSIN (OR LIMOSIN)

French, Limoges, 1546

Painted enamel on copper, partly gilded

7⁹⁄₁₆ × 5⅝ in. (19.2 × 14.3 cm)

Henry Clay Frick Bequest (1916.4.17)

Active in the 1520s–70s, Léonard Limousin transcended the traditional boundaries of his profession, achieving international fame. Introduced at the court of Francis I at Fontainebleau in the 1530s, he was named "enameler to the king" by Henry II in 1548. Signed LL and dated 1546, this plaque may depict Guillaume Farel (1489–1565), one of the leading figures, along with John Calvin (1509–1564), of the Protestant Reformation. It could well have been made to celebrate the ten-year anniversary of Farel's conversion of most of western Switzerland, including Geneva and Lausanne.

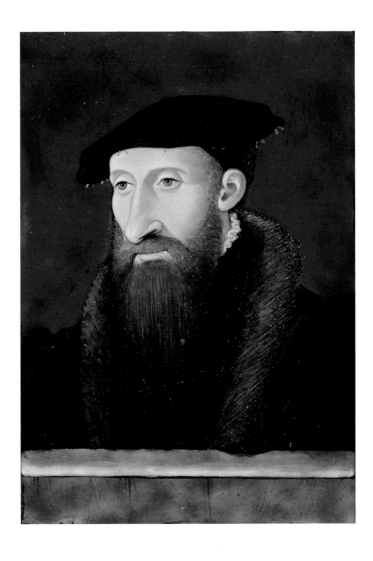

Portrait of a Man (Antoine de Bourbon?)

LÉONARD LIMOUSIN (OR LIMOSIN)
French, Limoges, ca. 1560
Painted enamel on copper, partly gilded
5⅛ × 4½ in. (13 × 11.4 cm)
Henry Clay Frick Bequest (1916.4.18)

Signed by Limousin, this plaque is most likely a depiction of Antoine de Bourbon, Duke of Vendôme, father of Henry IV, and King of Navarre from 1555 to 1562. Political turmoil led him to convert to Calvinism, but he returned to Catholicism shortly before his death in 1562, during the Counter-Reformation. Small enough to be held in one hand, this plaque demonstrates Limousin's ability to render faces in works that emulate the drawn and painted portraits by the French court painters Jean and François Clouet. The identification and dating of this enamel are based on a drawing at the Musée Condé by the atelier of François Clouet.

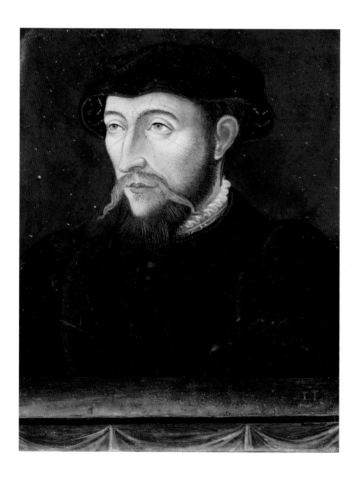

The Triumph of the Eucharist and the Catholic Faith

LÉONARD LIMOUSIN (OR LIMOSIN)
French, Limoges, 1561–62
Painted enamel on copper, partly gilded
7¾ × 10 in. (19.7 × 25.4 cm)
Henry Clay Frick Bequest (1916.4.22)

This ambitious plaque is a propagandistic, if
private, retelling of the shifting religious ideals
and political struggles of the powerful Guise
family. In the center is Jean de Guise, Cardinal of
Lorraine, in a red robe and biretta, walking beside
his older brother, Claude, first Duke of Guise.
Behind the brothers—both of whom died in 1550,
more than ten years before the plaque was
commissioned—a chariot carrying Claude's wife,
Antoinette de Bourbon, tramples a group of
Protestant heretics as she displays a chalice and
host. This scene represents the triumph of the
doctrine of transubstantiation—the belief in the
transformation of the bread and wine of the
Eucharist into the actual body and blood of Christ—
a central issue of the Counter-Reformation and
French Wars of Religion. Antoinette's eldest son,
François, second Duke of Guise, pushes the
triumphal procession forward while the youngest,
Charles, Cardinal of Lorraine, walks toward them
with a text in his hands, offering a compromise to
the Catholic Church's controversial position on the
Eucharist. Charles's personal emblem and motto—
an ivy-covered obelisk bearing the Latin phrase
TE STANTE VIREBO (With you standing, I shall
flourish)—are painted at the right.

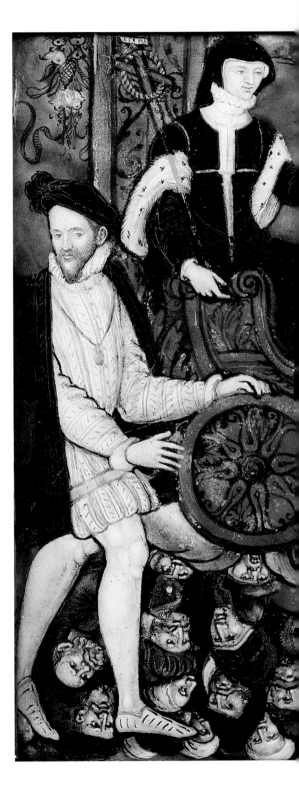

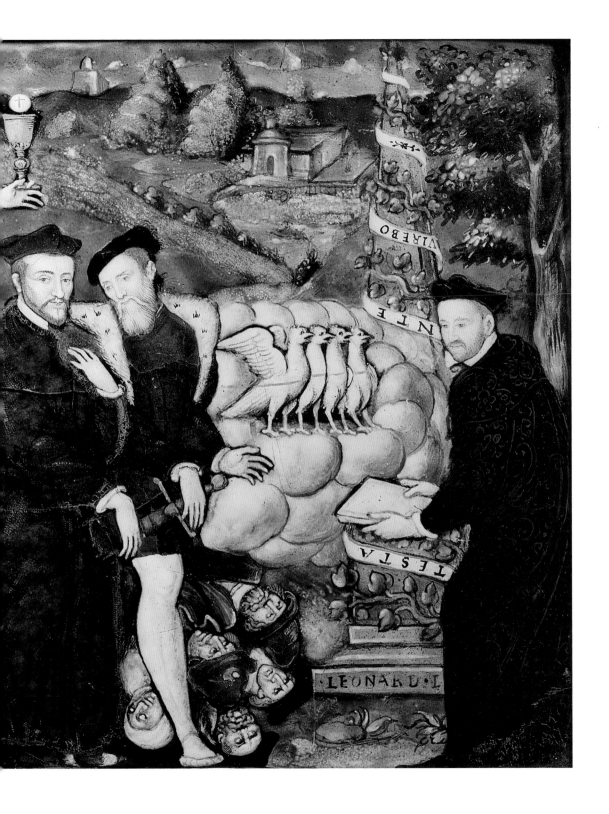

The Seven Sorrows of the Virgin

WORKSHOP OF PIERRE REYMOND
French, Limoges, 1533
Painted enamel on copper, partly gilded
7⅛ × 5¾ in (18.1 × 14.6 cm)
Henry Clay Frick Bequest (1916.4.11)

First appearing in French manuscript illumina-
tions, the subject of the Seven Sorrows of the
Virgin posits the suffering of the Virgin as equiva-
lent to that endured by Christ. Her seven sorrows,
illustrated here in roundels, are the Circumcision,
the Flight into Egypt, the Loss of the Child in
Jerusalem, Christ Falling on the Way to Calvary,
the Crucifixion, Mary receiving the dead body of
her child, and, finally, the Entombment. The
scenes of the Flight into Egypt and the Way to
Calvary derive from woodcuts by Albrecht Dürer
made before 1506 and in 1509, respectively. Dated
1533, this plaque may be the oldest known enamel
produced in the workshop of the prolific and
talented Pierre Reymond, who was active until the
early 1580s.

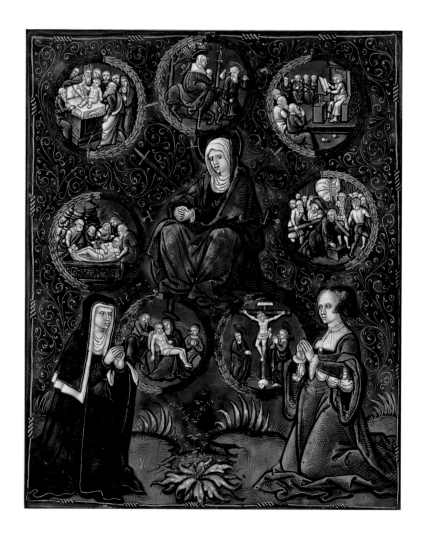

Two Plaques: The Agony in the Garden;
Christ Crowned with Thorns

WORKSHOP OF PIERRE REYMOND
French, Limoges, mid- to late sixteenth century
Painted enamel on copper, partly gilded
Plaques: 8 × 6¼ in. (20.3 × 15.9 cm)
Roundels: diam. 2¹/₁₆ in. (5.2 cm)
Gift of Dr. and Mrs. Henry Clay Frick, II, 2005
(2005.4.01–02)

These enamels may have originally been a pair or part of a larger altarpiece. Although they were painted by different hands, analysis of the blue enamel in each plaque reveals that they were made in the same workshop and at about the same time. Both depict an episode from the Passion of Christ. In *The Agony in the Garden,* Jesus kneels in prayer while the saints Peter, John, and James sleep in the foreground. The emphasis is on Jesus' impending arrest, with Judas and an army approaching on a grassy path painted in a rich blue-green. In the *Christ Crowned with Thorns* enamel, two tormentors use their weapons to drive the crown of thorns into Christ's head while a third mocks Christ by placing a reed in his hand as if it were a scepter. The plaques' monochromatic palette, dominated by white and gray tones, recalls early enamels in grisaille (a technique using shades of gray) by Pierre Reymond.

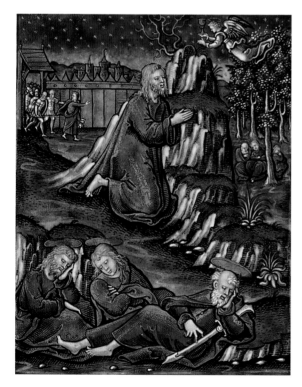

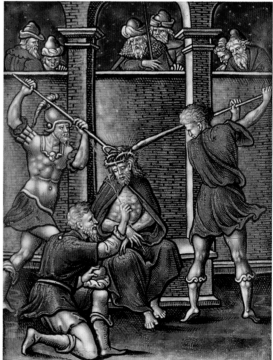

Casket: Old Testament Subjects

ATTRIBUTED TO THE WORKSHOP OF
PIERRE REYMOND
French, Limoges, mid-sixteenth century,
with later additions
Painted enamel on copper, partly gilded, and gilt-brass
4½ × 6½ × 4½ in. (11.4 × 16.5 × 11.4 cm)
Henry Clay Frick Bequest (1916.4.24)

This casket is composed of fourteen enameled plaques painted in grisaille and lightly tinted with rose, yellow, blues, and purples. The Old Testament scenes depicted include on the front the stories of Tubal-cain and his half-brother Jubal working at an anvil while their sister Naamah strums a gittern (see detail); three angels comforting Daniel in the lions' den as the prophet Habakkuk brings him food; Moses' spies carrying grapes from the Promised Land; and Lot plied with wine by his daughters. These plaques, and those on the sides and top of the casket, were almost certainly painted in Pierre Reymond's workshop in the 1540s; however, a different enameler made the four plaques on the back. The fourteen plaques were most likely mounted together on this casket in the nineteenth century.

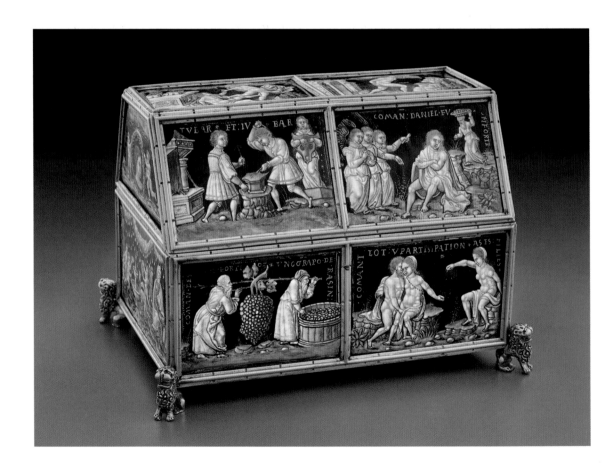

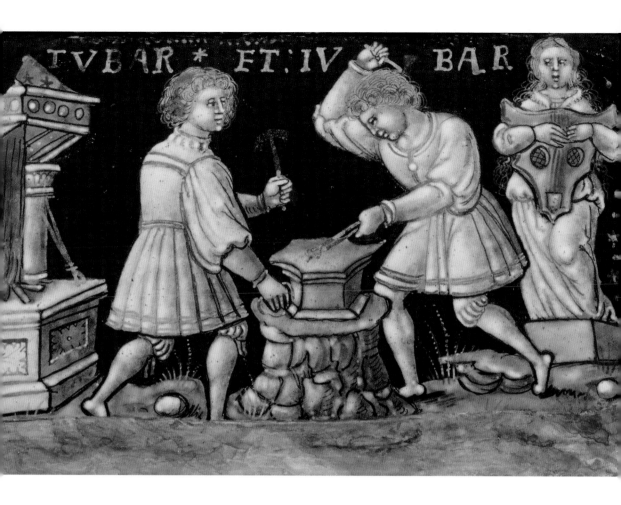

Saltcellar: Amorini and Satyrs

ATTRIBUTED TO THE WORKSHOP
OF PIERRE REYMOND
French, Limoges, mid-sixteenth century
Painted enamel on copper, partly gilded
H. 5⁹⁄₁₆ in. (14.1 cm), diam. 3½ in. (8.9 cm)
Henry Clay Frick Bequest (1916.4.27)

In the mid-sixteenth century, Limoges enamelers began to produce non-religious objects such as plates, ewers, cups, and saltcellars in grisaille. The workshop of Pierre Reymond specialized in such objects, which were collected throughout Europe. Kept in a private cabinet or on a sideboard during a formal banquet, these pieces were not used for food or to contain water, wine, or salt but rather were appreciated as decorative objects. Italian classical models, then highly fashionable in France, inspired the baluster form of this saltcellar, as well as its decorative motifs composed of satyrs, naked cherubs (amorini or putti), grotesques (fantastical figures and animals), and figures in medallions.

Ewer Stand: Moses Striking the Rock

WORKSHOP OF PIERRE REYMOND
French, Limoges, late sixteenth century
Painted enamel on copper, partly gilded
H. 1½ in. (3.8 cm), diam. 18 in. (45.7 cm)
Henry Clay Frick Bequest (1916.4.25)

The main scene of this stand derives from
woodcuts by Bernard Salomon, first published
in *Quadrins historiques de la Bible* and *Biblia*
Sacra in 1553 and 1554, respectively. Moses is
identifiable by his horns and staff, which he uses
to strike the rock and produce water. A procession
of Israelites waiting to fill their jugs crowds the
rest of the composition. The initials P·R on the
rim stand for Pierre Reymond, whose workshop
signed about fifteen ewer stands painted in
grisaille between 1557 and 1566. This colorful
example was probably made at the end of
Pierre Reymond's career, when he returned
to a chromatic palette.

Ewer: The Gathering of Manna; The Destruction of Pharaoh's Host

WORKSHOP OF PIERRE OR JEAN REYMOND

French, Limoges, late sixteenth century

Painted enamel on copper, partly gilded

13 × 6 × 4 in. (33 × 15.2 × 10.2 cm)

Henry Clay Frick Bequest (1916.4.26)

Biblical themes from the Old Testament grew in popularity during the sixteenth century. This ewer tells two stories from the Book of Exodus: on the shoulder is the episode during which the Israelites collect the manna that falls to earth after they complain to Moses of hunger, a story frequently represented on Limoges enamels. On the body of the ewer is a depiction of the destruction of the Pharaoh's armies after the Israelites cross the Red Sea. This ewer could be a late work by Pierre Reymond, who signed several vessels of the same shape but decorated in grisaille; however, the rich repertoire of decorative motifs recalls the work of Jean Reymond.

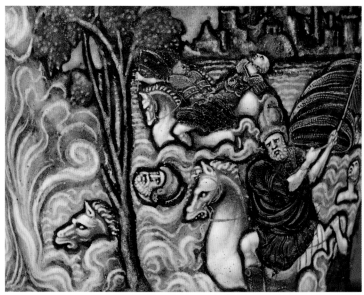

The Adoration of the Magi

ATTRIBUTED TO JEAN REYMOND
French, Limoges, late sixteenth century
Painted enamel on copper, partly gilded
11⅞ × 9½ in. (30.2 × 24.1 cm)
Henry Clay Frick Bequest (1916.4.28)

In this plaque, two kings stand at the left, one pointing behind him toward the North Star while the third kneels at the feet of the Holy Family to present a gift. The presence of an African king in Adorations of the Magi was first seen in northern European paintings before being adopted by Limoges enamelers. The attribution to Jean Reymond is based on close stylistic and technical similarities with enamels signed by him, including the Last Supper dish in The Frick Collection (p. 28).

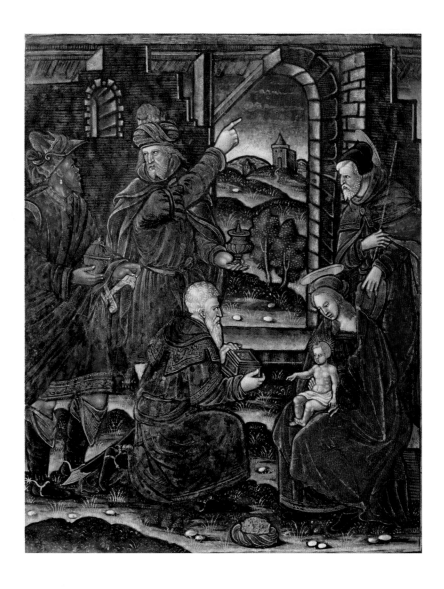

Oval Dish: The Last Supper; Jupiter

JEAN REYMOND

French, Limoges, late sixteenth century

Painted enamel on copper, partly gilded

20⅜ × 16 × 2 in. (51.8 × 40.6 × 5.1 cm)

Henry Clay Frick Bequest (1916.4.31)

This highly decorated oval dish is signed with the initials I·R for Jean Reymond, active in Limoges in the second half of the sixteenth century. The setting of the Last Supper in the courtyard of a palace derives from Italian models although the exact source remains unidentified. The figure of Jupiter on the back is after a print by the Italian engraver Marcantonio Raimondi. Like other enamelers in the Reymond family, Jean Reymond surrounds the main scene and subject with grotesques after prints by the French goldsmith and engraver Étienne Delaune, whose work helped disseminate the style of the Fontainebleau school among artists and craftsmen in France and abroad.

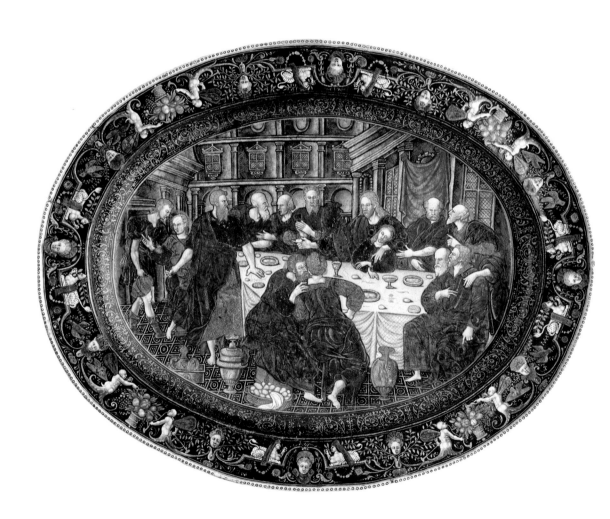

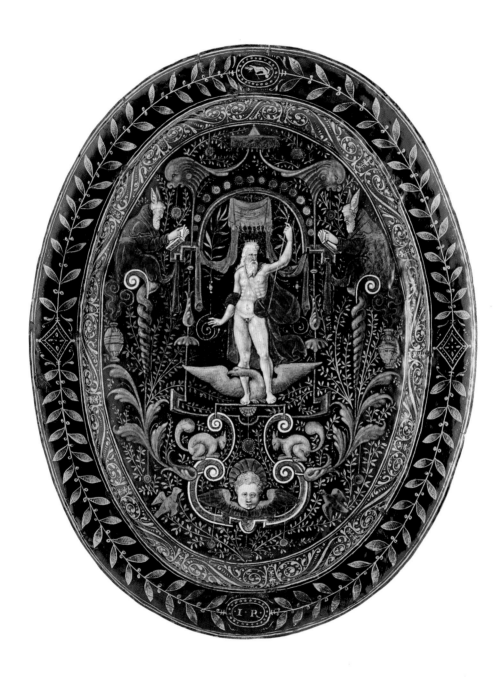

Oval Dish: Apollo and the Muses; Fame

MARTIAL REYMOND

French, Limoges, late sixteenth century

Painted enamel on copper, partly gilded

21 $\frac{7}{16}$ × 16 × 2 in. (54.4 × 40.6 × 5.1 cm)

Henry Clay Frick Bequest (1916.4.29)

Little is known about Martial Reymond, who signed this large dish. Son of Jean Reymond, he followed his father's style and technique in creating a decorative piece characteristic of the second half of the sixteenth century. Particularly representative of this artistic period is the combination of a mythological scene—here, Apollo surrounded by muses playing music—with fanciful figures and fantastic animals, known as grotesques. This exemplifies the arts that flourished at the court of Francis I at Fontainebleau under the influence of Italian artists brought to France in the 1530s and 1540s and which had a significant impact on Limoges enamelers of the next generation.

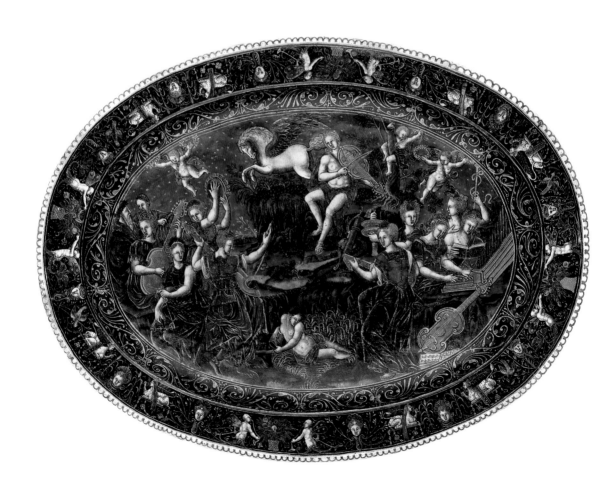

Casket: Scenes from the Story of Joseph

PIERRE COURTEYS
French, Limoges, late sixteenth century
Painted enamel on copper, partly gilded
9⅜ × 10⅝ × 6¾ in. (23.8 × 27 × 17.1 cm)
Henry Clay Frick Bequest (1916.4.32)

This casket is decorated with seven plaques, each of which depicts an episode of the Story of Joseph from the Book of Genesis. Following the biblical text chronologically, the scenes are painted after woodcuts by Bernard Salomon, first published in 1553 in *Quadrins historiques de la Bible* by Jean de Tournes and in various bibles issued afterward by the same publisher. Because of the clarity of Salomon's illustrations, the story of Joseph became a recurrent source of inspiration for Limoges enamelers in the second half of the sixteenth century, among them, Pierre Reymond, Jean de Court, Suzanne de Court, and Pierre Courteys, who signed this casket.

Cup: Moses Striking the Rock

MASTER IC

French, Limoges, late sixteenth century

Painted enamel on copper, partly gilded

H. 4⅜ in. (10.9 cm), diam. 10 in. (25.4 cm)

Henry Clay Frick Bequest (1916.4.38)

This cup (or tazza) and the one on page 34 are signed with the initials IC, probably a member of the Court family of Limoges enamelers, also known as Court dit Vigier and Vigier dit Court. The undersides of both cups are decorated with arabesques in gold, strapwork in grisaille, and human masks with peach washes—all painted over dark enamel (see detail). The interior scenes are from the Book of Exodus after a woodcut by Bernard Salomon, in *Quadrins historiques de la Bible*. Here, Moses strikes the rock at Mount Horeb to produce water for the starving and thirsty Israelites.

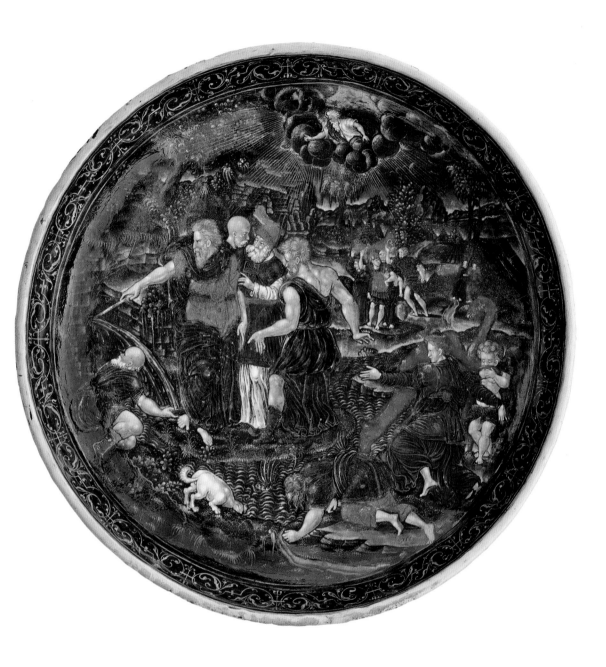

Cup: Lot and His Daughters

MASTER IC

French, Limoges, late sixteenth century

Painted enamel on copper, partly gilded

H. 4⅞ in. (11.1 cm), diam. 9⅞ in. (25.1 cm)

Henry Clay Frick Bequest (1916.4.39)

The inscription G XIX (Genesis 19) at the top of the scene identifies the story of Lot and his daughters from the Old Testament. Fearing for the continuation of their family line after the fall of Sodom, Lot's two daughters entice, inebriate, and seduce him. Lot's wife stands far off, with Sodom in the distance. She is the only figure painted in grisaille, suggesting that she has already been turned into a pillar of salt, her punishment for having looked back at Sodom as she and her family escaped the city. Gilt details enhance the composition, particularly the burning city of Sodom and the brightly painted bridge leading there.

Ewer: Triumph of Bacchus; Triumph of Diana

MASTER IC

French, Limoges, late sixteenth century

Painted enamel on copper, partly gilded

11⅛ × 6¾ × 5 in. (28.3 × 17.1 × 12.7 cm)

Henry Clay Frick Bequest (1916.4.35)

Signed IC on the lip, this ewer depicts two pagan
subjects on its ovoid body: on the upper register,
the triumph of Bacchus; and on the lower register,
the triumph of Diana. Both were adapted from
designs for the decoration of cups, ewers, and ewer
stands made around 1546 by the French architect,
designer, and engraver Jacques Androuet du
Cerceau (1510–1584). This demonstrates the lasting
influence on late sixteenth-century Limoges enamels
of the arts that flourished in the 1530s and 1540s at
the court of Francis I at Fontainebleau.

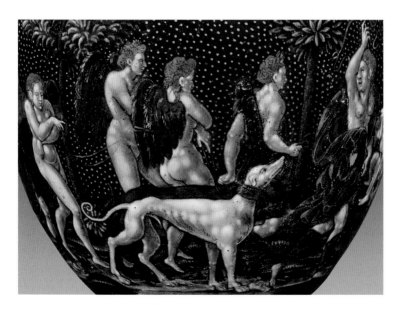

Candlestick: Olympian Deities and the Labors of Hercules

MASTER IC

French, Limoges, late sixteenth century

Painted enamel on copper, partly gilded

H. 11¼ in. (29.8 cm), diam. 8½ in. (20.6 cm)

Henry Clay Frick Bequest (1918.4.36)

Called *à la romaine* (in the Roman manner), candlesticks with a high vertical stem were among several types made in Limoges enamels. The originality of this piece lies in its large base with raised oval medallions. The twelve roundels at the base depict Olympian gods and goddesses alternating with six of the labors of Hercules. The gods and goddesses derive from prints by Étienne Delaune, while the labors of Hercules were painted after engravings by Heinrich Aldegrever from 1550. It is very likely that a second candlestick completed the iconographic program with the six remaining labors of Hercules and a different set of gods and goddesses. The candlestick is signed IC, in gold, inside the foot.

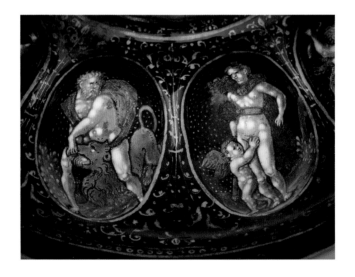

Adoration of the Shepherds

MASTER IDC

French, Limoges, late sixteenth
or early seventeenth century

Painted enamel on copper, partly gilded

17½ × 13⁷⁄₁₆ in. (44.5 × 34.1 cm)

Henry Clay Frick Bequest (1916.4.34)

This large plaque is inscribed with the initials IDC, thought to refer to Jean de Court, a late sixteenth- to early seventeenth-century enameler. This masterpiece reproduces Agnolo Bronzino's *Adoration of the Shepherds*, a painting executed in 1530–40 for a Florentine patron and known in France through prints. In fact, the enameler copied almost exactly an engraving after the painting by Giorgio Ghisi. Ghisi reversed the original composition and added Latin inscriptions, the two birds on the roof of the manger, the extensive architecture of Bethlehem in the background, and the mannerist rendering of the figures (most noticeable in the muscular back of the crouching shepherd in the foreground).

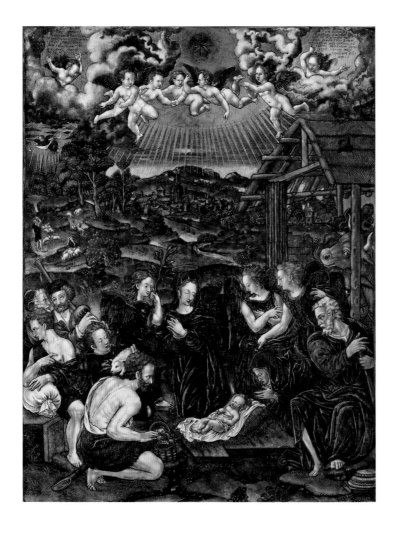

Pair of Saltcellars: Scenes from the Story of Orpheus

SUZANNE DE COURT
French, Limoges, late sixteenth
or early seventeenth century
Painted enamel on copper, partly gilded
Each, h. 3½ in. (8.9 cm), diam. 3⁹⁄₁₆ in. (9 cm)
Henry Clay Frick Bequest (1916.4.43–44)

These two saltcellars are marked with the initials SC for Suzanne de Court, the only known female enameler in sixteenth-century Limoges. The decoration is after woodcuts attributed to Bernard Salomon that were first published in Lyon in 1557 to illustrate Ovid's *Metamorphoses*. On one saltcellar, the furious women of Cicones attack Orpheus because he has decided to avoid mortal women after the loss of his beloved wife, Eurydice (see detail). But their spears are stopped by the magic of his music and fall harmlessly at his feet. The

story continues on the second saltcellar, with Orpheus slain and his head thrown into the River Hebrus while three women mourn his death. In the final scene, Apollo turns the dragon that sought to devour Orpheus's head into stone. Saltcellars like these and those on the following page were likely not intended to hold salt but were instead displayed on tables and sideboards during banquets.

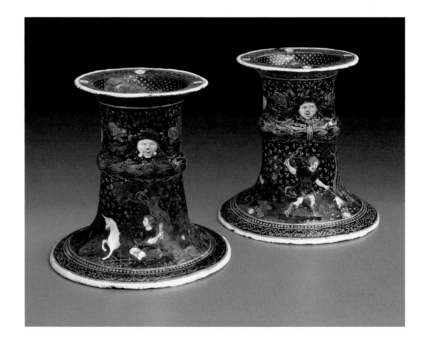

Pair of Saltcellars: The Story of Minos and Scylla, and Allegorical Figures

JEAN GUIBERT

French, Limoges, early seventeenth century

Painted enamel on copper, partly gilded

Each, h. 4⅜ in. (11.1 cm), diam. 6 in. (15.1 cm)

Henry Clay Frick Bequest (1916.4.40-41)

Little is known of Jean Guibert, who signed these saltcellars with his initials JG. He seems to have enameled a handful of pieces that, like these, are decorated with stories after Ovid's *Metamorphoses*. Inside one of these receptacles, he depicts King Minos of Crete on his horse and Scylla—the daughter of his enemy, King Nisus of Megara—after an illustration by Crepin de Passé, published in 1602. The second receptacle depicts Scylla betraying her father by giving Minos, with whom she has fallen in love, Nisus's magical hair, which provided invincibility. This scene is after a 1557 woodcut attributed to Bernard Salomon. The six sides of each saltcellar are painted with allegorical figures after Étienne Delaune representing Faith, Hope, Charity, Fortitude, Temperance, Dialectic, Religion, Justice, Prudence (see detail), Poetry, Medicine, and Astronomy.

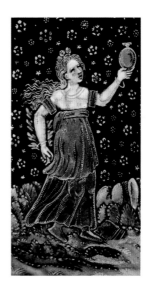

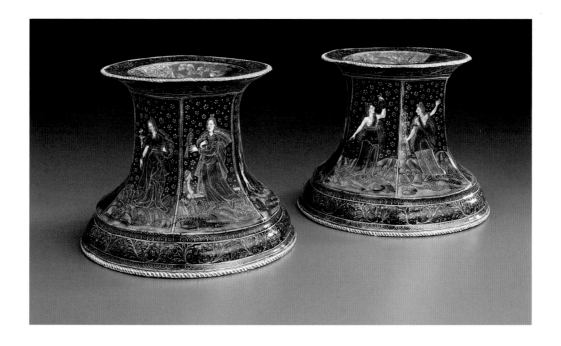

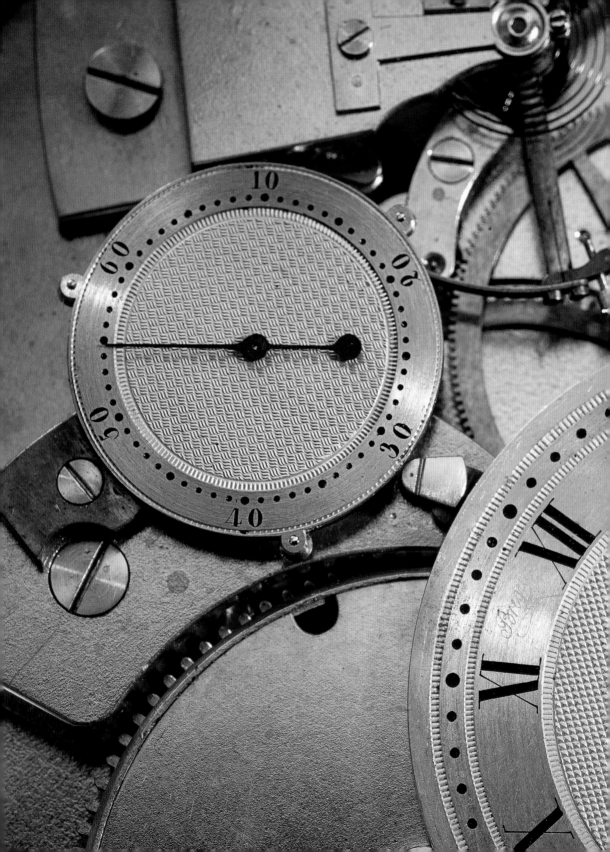

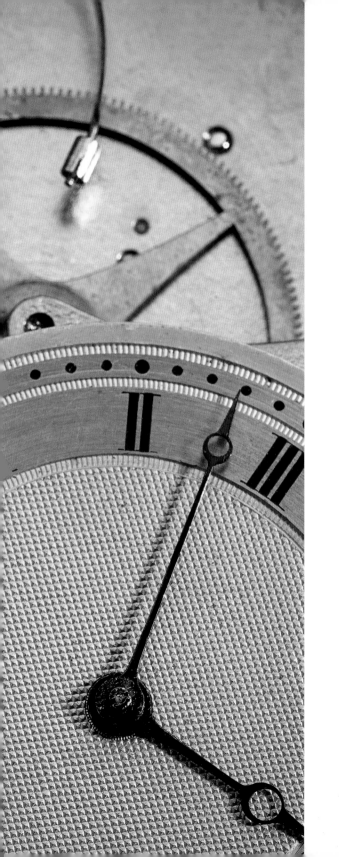

Clocks
and Watches

Clock

PIERRE DE FOBIS

French, probably Aix-en-Provence, ca. 1530
Gilt brass and enamel
5 × 2¾ × 2¾ in. (12.7 × 7 × 7 cm)
Bequest of Winthrop Kellogg Edey, 1999 (1999.5.129)

One of the most famous French clockmakers of his
time, Pierre de Fobis is still recognized today for his
durable and highly refined movements. This clock
is among Fobis's rare extant works and one of the
earliest surviving spring-driven timekeepers. It
incorporates the latest discoveries of the day: a
coiled spring that provides energy to power the
clock's mechanism; a verge escapement that
regulates the rate at which energy is delivered to
the oscillator (at the time, this was a simple
balance); and a fusée, a cone-shaped spindle that
equalizes the diminishing force of the coiled spring
as it unwinds. The complex movement is set into a
typical sixteenth-century French clock case
inspired by classical architecture and ornament.

Portable Clock

German, probably Augsburg, ca. 1550
Gilt brass
H. 1½ in. (3.9 cm), diam. 2⅜ in. (6.1 cm)
Bequest of Winthrop Kellogg Edey, 1999 (1999.5.135)

Portable timekeepers could not be produced until clockmakers were able to reduce the size of the mechanism, and the first successful attempt is believed to have been in Italy around 1500. Throughout the sixteenth century, portable clocks, often in the shape of small drums, were made elsewhere in Europe, notably Augsburg, Germany, which became a leading producer of clocks during the Renaissance. This early example has small touch pins at each hour to allow the user to tell time at night by simply feeling the position of the hour hand. Over the next fifty years, the drum clock evolved into the more convenient pendant watch.

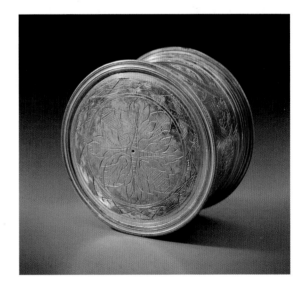

Clock with Astronomical and Calendrical Dials

VEYT SCHAUFEL

German, Munich, 1554

Gilt brass

12⅛ × 7⅜ × 5⁵⁄₁₆ in. (31.4 × 18.8 × 13.2 cm)

Bequest of Winthrop Kellogg Edey, 1999 (1999.5.130)

The clock completed at the conclusion of an apprentice clockmaker's long training was called a "masterpiece." It was only after the guild's acceptance of this expensive and challenging work that a craftsman could be qualified as a master and thus establish his own shop and sign his work. This clock, the earliest known signed and dated masterpiece, includes several astronomical and calendrical dials to provide time according to various systems. It is surmounted by a figure, possibly Minerva, the Roman goddess of wisdom, technical skill, and invention, identified with the Greek goddess Athena. In her right hand, she holds a church bell, and at her side stands a rooster. Before mechanical clocks were invented, the bell's toll and the rooster's morning crow traditionally kept time.

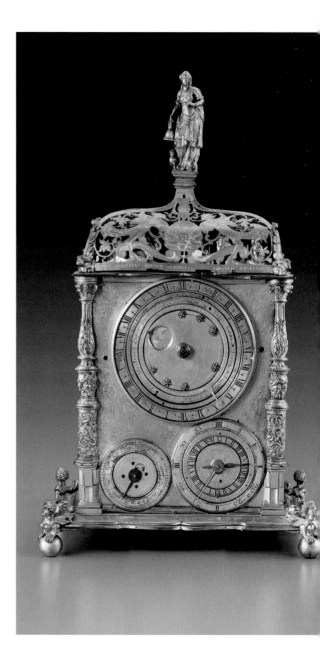

Clock

Flemish, Flanders, ca. 1565
Gilt brass
2⁷⁄₁₆ × 5³⁄₁₆ × 5¼ in. (6.2 × 13.2 × 13.3 cm)
Bequest of Winthrop Kellogg Edey, 1999 (1999.5.131)

By the mid-sixteenth century, spring-driven clocks
were not uncommon. This clock, inscribed
BRUSSEL on the case, is one of only a handful that
has survived from Flanders. The pierced window
on its side allows for viewing the mechanism
during winding.

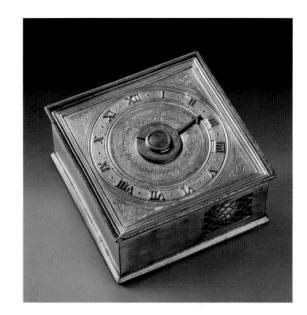

Clock

German, probably Augsburg, ca. 1580
Gilt brass
9¾ × 7⅛ × 7⅛ in. (24.8 × 18.1 × 18.1 cm)
Bequest of Winthrop Kellogg Edey, 1999 (1999.5.134)

This ornamented double-domed clock is made of
cast, pierced, and chased gilded brass. Four winged
harpies support the clock and, in a simplified
version, the double dome. Bare-breasted women
supporting capitals decorate the corners of the
case while the dials and panels are richly orna-
mented with foliate designs. The front panel
incorporates the face of a man, probably repre-
senting the moon. The double dome is also richly
decorated with pierced foliage. The finial (now
missing) was likely a figure or a spire.

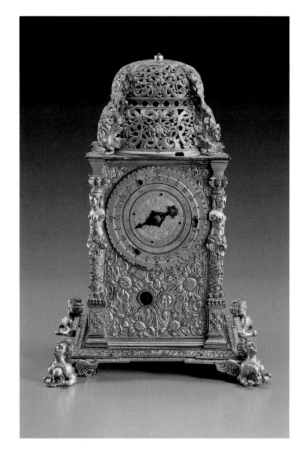

Clock with Astronomical and Calendrical Dials

DAVID WEBER

German, Augsburg, probably 1653

Gilt brass and silver

23⅛ × 10¹⁄₁₆ × 9⅞ in. (59.4 × 25.5 × 25.1 cm)

Bequest of Winthrop Kellogg Edey, 1999 (1999.5.144)

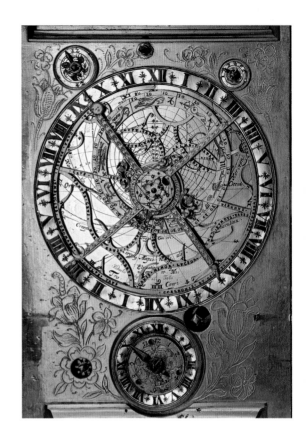

Most likely made for his admission to the Augsburg clockmakers guild, this impressive table clock exemplifies David Weber's great expertise. The complex mechanism includes seven dials that provide astronomical, calendrical, and horary information. The prominent central dial on the front (see detail)—an astronomical device called an astrolabe—features twenty-one star pointers and two concentric hands that correspond to the sun and moon. The smaller dial beneath it is an alarm. Although Weber chose the popular tower form for the clock's case, he demonstrated his skill and inventiveness in its finely worked surfaces. His silver and brass floral arrangements and figures exhibit brilliant chasing (a technique in which the malleable metal is pushed inward to create tiny grooves for texture) and repoussé (hammering the metal from the reverse side in order to create a design in relief).

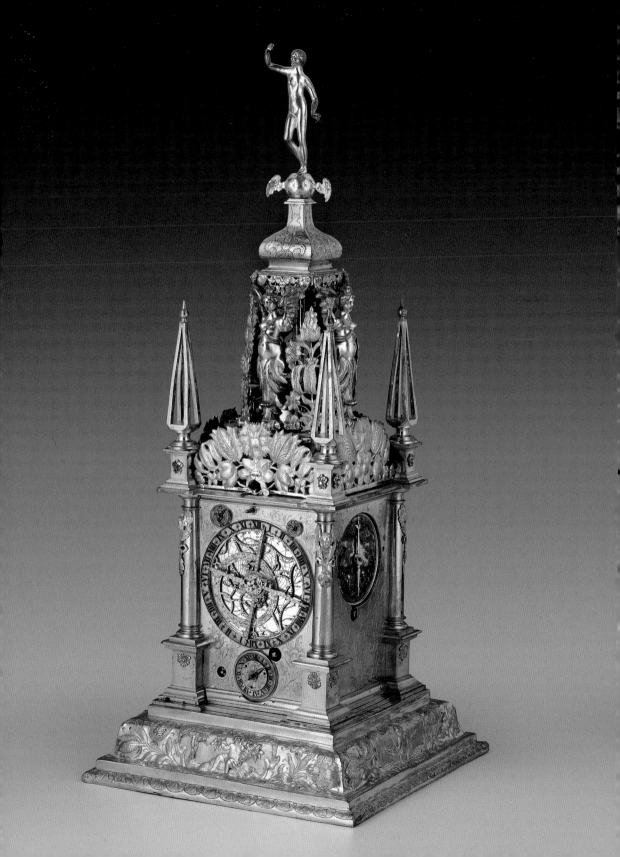

Watch

C. DE LESPÉE
French, Reims, ca. 1620
Gold, rock crystal, and enamel
2⅝ × 1⁹⁄₁₆ × 1¹⁄₁₆ in. (6.6 × 3.9 × 2.8 cm)
Bequest of Winthrop Kellogg Edey, 1999 (1999.6.18)

By about 1580, the drums of the first portable
timekeepers had evolved into more convenient
pendant watches that could be worn on a chain
suspended around the neck. However, they were
unreliable and valued primarily as luxury items
until 1675, when the balance spring was intro-
duced. With its rock crystal case and cloisonné
enamel decoration, this early French watch is
especially rare. Nothing is known of C. de Lespée,
whose name appears on the movement.

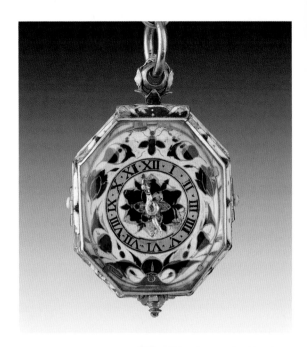

Calendrical and Astronomical Watch

GEORGE SMITH
English, London, ca. 1625
Silver and gilt brass
2⁷⁄₁₆ × 1⁷⁄₁₆ × 1 in. (6.2 × 3.6 × 2.5 cm)
Bequest of Winthrop Kellogg Edey, 1999 (1999.6.17)

Most sixteenth-century watches were made in
Germany and France, but during the early 1600s,
watchmaking centers began to flourish in other
countries. George Smith, the English maker of this
watch, entered the guild known as the Clockmakers'
Company in 1632, the year after its founding.
Smith is recorded as working "next to the New
Exchange" and having two apprentices (probably
John and Paul Jacob).

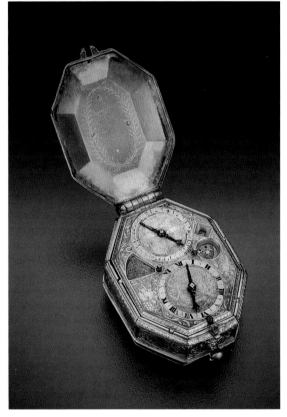

Watch

ABRAHAM GRIBELIN OR ISAAC GRIBELIN

French, Blois, ca. 1620

Silver

3¼ × 1⅞ × 1⅛ in. (8.4 × 4.8 × 3 cm)

Bequest of Winthrop Kellogg Edey, 1999 (1999.6.19)

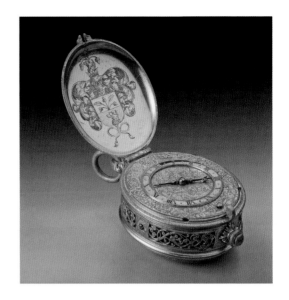

The silver dial plate of this watch is finely engraved with a gilt-brass chapter ring, roman numerals at the hours, and fleur-de-lis-type marks on the half hours. The area outside the chapter ring has a floral and foliate design with figures playing musical instruments: for example, at five o'clock, a gentleman playing a flute, behind whom is a soldier with a pike; at seven o'clock, a gentleman playing a drum followed by a soldier with a sword. The center of the dial illustrates an army encampment with a group of soldiers and a ruler wearing a laurel wreath; a figure in the background is committing suicide with a sword. The identification of these scenes is unclear. The sides of the case are silver, delicately engraved and pierced to emit the sound of a bell.

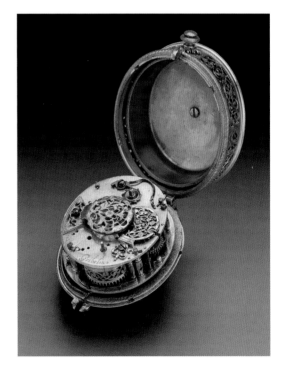

Watch

MOVEMENT BY CHAVANNES LE JEUNE
ENAMELING ATTRIBUTED TO PIERRE HUAUD
Swiss, Geneva, ca. 1660
Gold and enamel
1⅞ × 1⁵/₁₆ × 1¼ in. (4.7 × 3.3 × 3.2 cm)
Bequest of Winthrop Kellogg Edey, 1999 (1999.6.21)

By the late seventeenth century, the most sought
after watches were set into lavish enamel cases
that imitated miniature paintings on paper,
parchment, or ivory. The technique of painting
on enamel watchcases was developed in France,
notably in Blois and Paris about 1630, but soon
emerged in Geneva, thanks to Pierre Huaud, a
Protestant who had fled France and established
himself in Switzerland in the early seventeenth
century. Only one watchcase signed by Huaud has
survived; however, the distinctive colors and
style of this example allow for the Huaud attribu-
tion. The portrait on the back of the case is in the
style of the French seventeenth-century painter
Pierre Mignard.

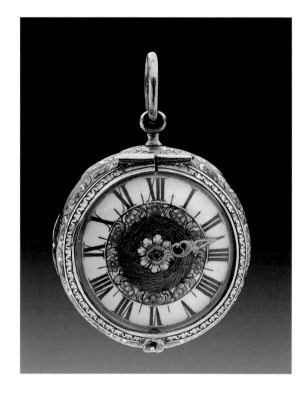

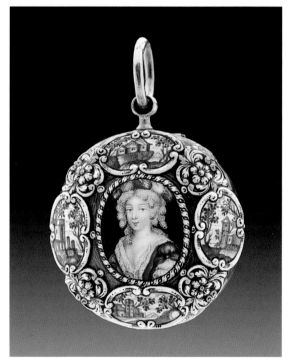

Watch

MOVEMENT BY HENRY ARLAUD

ENAMELING BY PIERRE HUAUD II

Swiss, Geneva, ca. 1685

Gold and enamel

2⁵⁄₁₆ × 1⁵⁄₈ × ¹⁵⁄₁₆ in. (5.9 × 4.1 × 2.4 cm)

Bequest of Winthrop Kellogg Edey, 1999 (1999.6.22)

This watchcase signed by Pierre Huaud II, the son of Pierre Huaud, exemplifies the high degree of skill required to produce minuscule detailed scenes. On the back is a reverse image of *The Toilet of Venus* by the French painter Simon Vouet. Pierre Huaud II never saw the original painting (now at the Carnegie Museum of Art, Pittsburgh) but rather based his composition on the engraving made in 1651 by Michel Dorigny. He enriched the black-and-white print with vivid colors—his family's trademark. This watchcase was made for a movement by Geneva-based clockmaker Henry Arlaud, whose signature is engraved on the back plate.

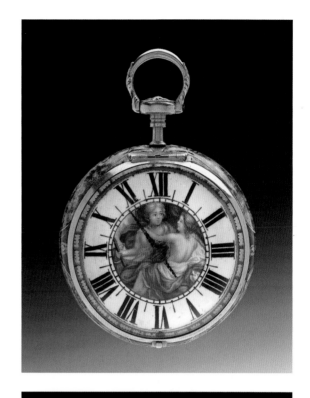

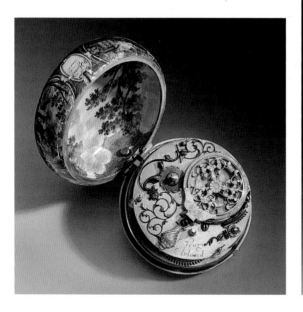

Longcase Clock

EDWARD EAST

English, London, ca. 1675–80

Olive wood and brass on oak, walnut, and burl wood

79½ × 16⅛ × 9 in. (201.9 × 40.9 × 22.9 cm)

Bequest of Winthrop Kellogg Edey, 1999 (1999.5.141)

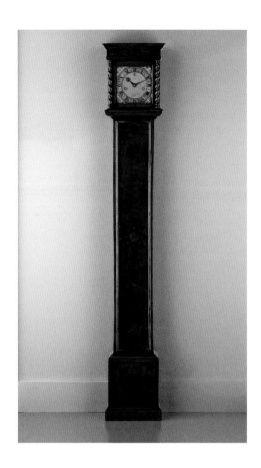

The pendulum clock was invented in 1653 by the Dutch mathematician Christiaan Huygens, but it was developed, soon after, in England and France. This innovation transformed clocks into precise timekeepers. However, it was not until around 1669 that a type of escapement was invented that enabled pendulum clocks to keep time within a few seconds. One of the first English clockmakers to produce pendulum clocks, Edward East was appointed an assistant in the Worshipful Company of Clockmakers, the English clockmakers guild, in 1632. He appears to have had a sizeable workshop and during his long career trained a number of clockmakers, including the celebrated Henry Jones. Such longcase clocks were introduced in England in the 1660s, and about twelve of them from the seventeenth century have survived.

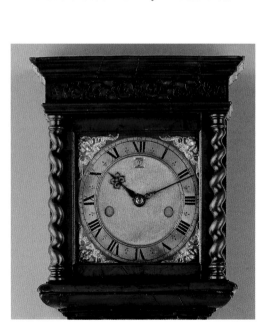

Clock

GEORGE GRAHAM

English, London, ca. 1695–97

Ebony and oak

11 5/16 × 6 15/16 × 4 13/16 in. (28.7 × 17.7 × 12.3 cm)

Bequest of Winthrop Kellogg Edey, 1999 (1999.5.149)

The most celebrated English clockmaker of his time, George Graham did much to establish England as the leader in the manufacture of clocks and watches. In 1696, a year after the completion of his apprenticeship, he went to work for England's most eminent clockmaker, Thomas Tompion, marrying Tompion's niece and inheriting his business when he died in 1713. This clock reflects the strong influence of Tompion's style. It also bears a number (272) that, according to Tompion's numbering system, dates it to between 1695 and 1697, making it an early work by Graham, perhaps begun when he was still in Tompion's employ.

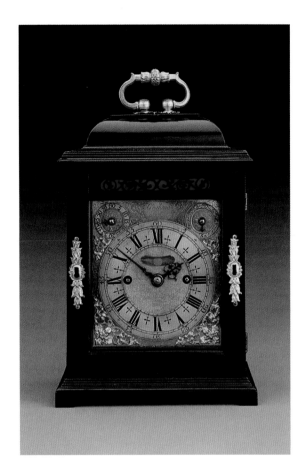

Longcase Clock

MOVEMENT BY ANTOINE GAUDRON

CASE ATTRIBUTED TO ANDRÉ-CHARLES BOULLE

French, Paris, ca. 1677

Ebony, turtle shell, and oak

88 × 15¹³⁄₁₆ × 7⅞ in. (223.5 × 40.2 × 20 cm)

Bequest of Winthrop Kellogg Edey, 1999 (1999.5.143)

For the English, the creation of the clock's movement was of primary interest while the French gave increasing importance to the case. This one was likely made by André-Charles Boulle, one of the greatest cabinetmakers of all time. Appointed *ebéniste du roi* (royal cabinet-maker) by Louis XIV in 1672, he had the privilege of working in one of the Palace of the Louvre workshops, which had been created by Henry IV for use by the most favored artists employed by the crown. This daily exposure to the leading artists and craftsmen of the time provided unparalleled intellectual stimulation and encouraged fruitful collaborations. For example, the gilt-bronze mount of Cronus found on this dial and on other early clocks by Boulle is thought to have been modeled by François Girardon, the great sculptor of Versailles.

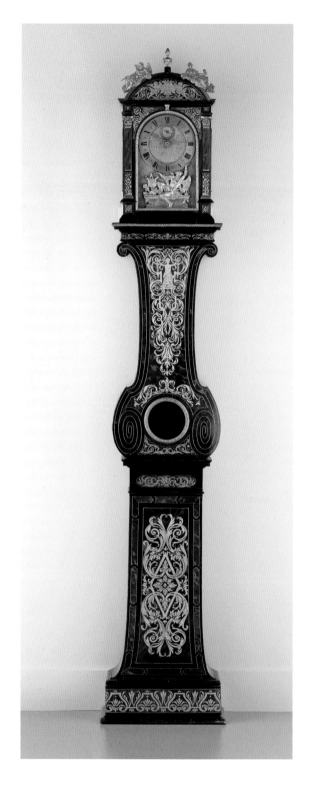

Tête de Poupée Clock

MOVEMENT BY BALTHAZAR MARTINOT II
CASE ATTRIBUTED TO ANDRÉ-CHARLES BOULLE
French, Paris, ca. 1680–90
Pewter, turtle shell, brass, oak, and pine
21⅛ × 11⅛ × 6⅞ in. (54.4 × 28.2 × 17.5 cm)
Bequest of Winthrop Kellogg Edey, 1999 (1999.5.147)

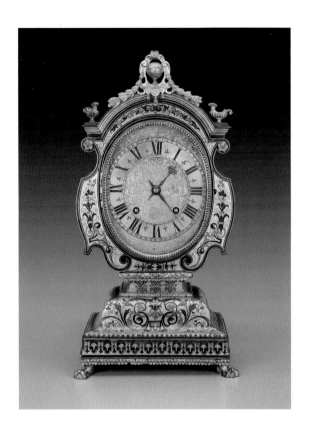

A gifted craftsman, André-Charles Boulle was
also a creative designer who invented new types
of clocks and furniture, including a mantel clock
called *tête de poupée* (doll's head clock) because
its profile resembles a figure's head and shoulders.
Popular in the late seventeenth century, these
clocks almost always combine a turtle-shell veneer
with engraved brass and pewter in the shape of
arabesques and foliage known as Boulle marque-
try, for which the cabinetmaker to Louis XIV
achieved international renown. When the back-
ground is in brass or pewter, as here, the marque-
try is said to be in *contre-partie*. When turtle shell
serves as the background, the marquetry is in
première-partie. Boulle often collaborated with
the clockmaker Balthazar Martinot II, who signed
this movement. Martinot supplied clocks to his
aristocratic and wealthy French clientele, as well
as to the King of Siam.

Barometer Clock

MOVEMENT BY ISAAC THURET OR
JACQUES THURET

CASE BY ANDRÉ-CHARLES BOULLE

French, Paris, ca. 1690–1700

Ebony, turtle shell, brass, gilt bronze, and enamel

45¼ × 23⅛ × 10¼ in. (114.9 × 58.7 × 26 cm)

Bequest of Winthrop Kellogg Edey, 1999 (1999.5.148)

This clock illustrates the high degree of crafts-
manship and originality in the designs of the
artisans who served Louis XIV. The movement, by
either Isaac Thuret or his son, Jacques Thuret—
each of whom held the position of clockmaker to
the king—is set within a case by André-Charles
Boulle, the celebrated cabinetmaker to Louis XIV.
Both the Thurets and Boulle occupied workshops
in the Palace of the Louvre. Their royal appoint-
ments made it possible to work outside the strict
regulations of the French guild system, in which a
craftsman could open his own workshop only after
attaining the status of master. Such a workshop
produced objects exclusively within the specialty
of the master craftsman. A royal craftsman,
exempt from this rule, was free to cross boundar-
ies into other fields, therefore controlling all
aspects of the production from design to decora-
tion. For this barometer clock, Boulle not only
built the case—covering it with a turtle-shell
veneer with inlays of engraved brass and pewter—
he also designed, chased, and gilded the highly
original gilt-bronze mounts that adorn the piece.
He crowned the clock with a Greco-Roman oil
lamp with a satyr's head and placed an Egyptian
sphinx on each side of the base, which rests on
spiral turrets. Boulle's embrace of the antique—
classical and Egyptian—represents a central
aspect of the style that prevailed during the reign
of the Sun King.

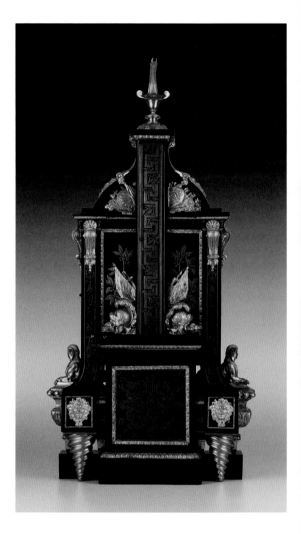

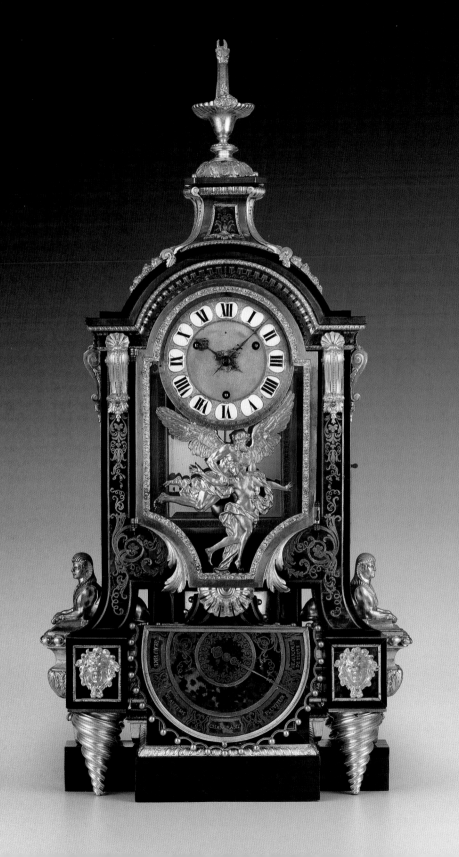

Watch

JULIEN LE ROY
French, Paris, ca. 1750
Gold and enamel
2¼ × 1¾ × 1¾ in. (5.8 × 4.5 × 4.4 cm)
Bequest of Winthrop Kellogg Edey, 1999 (1999.6.24)

After ninety years of civil and religious freedom,
the Huguenots were once again persecuted after
the Edict of Nantes was revoked in 1685. Many of
them immigrated to neighboring countries,
resulting in the loss of much of the clock and
watchmaking workforce. France's eventual
recovery in the manufacture of clocks and watches
was due in part to Julien Le Roy, who did much to
re-establish Paris as a leading center for horology.
In his extensive workshops, Le Roy created fine
and precise movements set in luxurious and
fashionable clocks and watchcases, like this one
decorated in gold and cloisonné enamel.

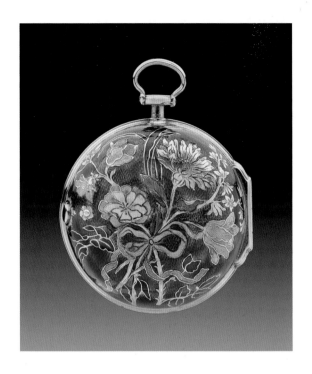

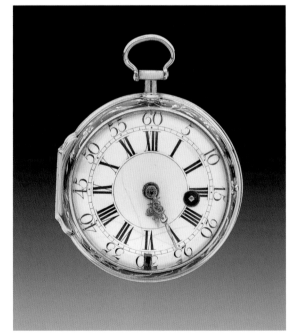

Watch

FRANÇOIS BEECKAERT
French, Paris, 1750–55
Gold and enamel
2¼ × 1¾ × 1¾ in. (5.8 × 4.5 × 4.4 cm)
Bequest of Winthrop Kellogg Edey, 1999 (1999.6.25)

Throughout the eighteenth century, watches were appreciated as both timekeepers and wearable pieces of jewelry. The highly accurate movement of this watch is set in a gold case decorated with polychrome enamels that depict a bouquet of roses, carnations, and tulips tied with a blue ribbon. Widely cultivated in France at this time, these flowers were often represented on women's clothing and objects. The hands of the watch are studded with jewels that resemble diamonds. The "fake" diamond, or rhinestone, was invented around 1730 by the Alsatian jeweler Georg Friedrich Strass. It was in great demand at the court of Louis XV, where Strass became the king's jeweler in 1734. François Beeckaert, who signed this watch, became a master clockmaker in Paris in 1746.

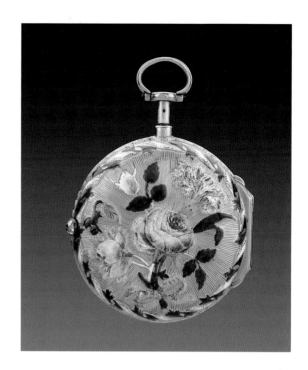

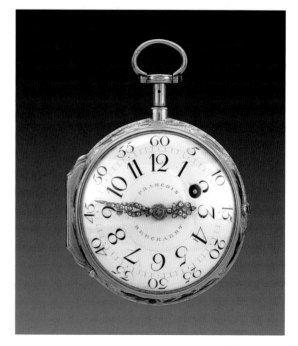

Watch

MOVEMENT BY THOMAS MUDGE

CASE BY JOHN GASTRILLE

English, London, 1757

Gold and enamel

2⅜ × 1¹⁵⁄₁₆ × 1¼ in. (6 × 4.9 × 4.4 cm)

Bequest of Winthrop Kellogg Edey, 1999 (1999.6.26)

Gold watches were sought after throughout eighteenth-century Europe. In England around 1750, repoussé was in fashion for luxury watches. John Gastrille mastered the technique on the case for this watch by Thomas Mudge, one of the greatest watchmakers in eighteenth-century England. Apprenticed to the celebrated clock, watch, and instrument maker George Graham, Mudge opened his own business, Dial and One Crown, on Fleet Street in London in 1750. Over the next twenty years, he made clocks and watches of the highest quality, incorporating the various technical innovations he had developed.

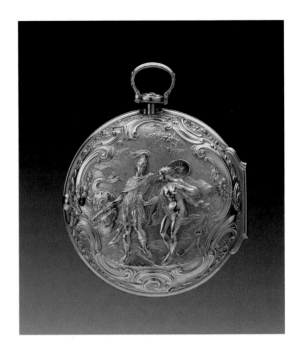

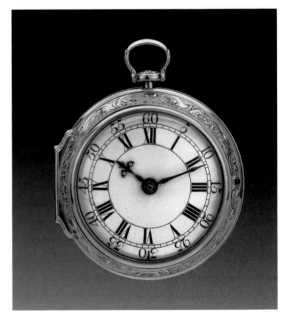

Watch

DUTERTRE

French, Paris, ca. 1765

Gold, gilt brass, enamel, and copper

2⅜ × 1⅞ × 1 in. (6 × 4.8 × 2.4 cm)

Bequest of Winthrop Kellogg Edey, 1999 (1999.6.27)

The movement of this watch is signed DUTARTRE A PARIS, which refers almost certainly to a member of the Dutertre dynasty of watch and clockmakers. At the time this watch was made, several Dutertres were active in Paris: the brothers Jean Baptiste, Jean Abraham, and Nicolas Charles Dutertre; and Nicolas Charles's two sons, Jean Baptiste and Charles Nicolas Dutertre. Watches decorated like this one, in various shades of gold, were particularly fashionable at the time. The colors were obtained by adding alloys to the precious metal; for example, copper, to achieve a pinkish tone.

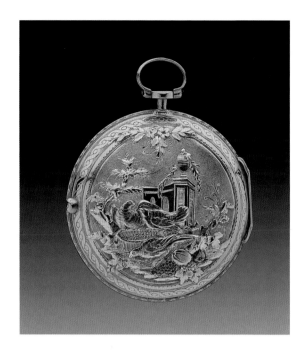

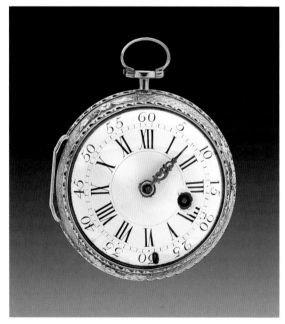

Longcase Regulator Clock and Barometer

MOVEMENT BY FERDINAND BERTHOUD
BRONZE MOUNTS BY PHILIPPE CAFFIÉRI
CASE BY BALTHAZAR LIEUTAUD
French, Paris, 1767
Oak veneered with various woods including tulipwood,
kingwood, and amaranth; gilt bronze, enamel, and marble
100 × 21¼ × 13⅝ in. (254 × 55.5 × 34.5 cm)
Henry Clay Frick Bequest (1915.5.46)

Ferdinand Berthoud's highly accurate movement
and the design of Balthazar Lieutaud and Philippe
Caffiéri combined to produce this sophisticated
clock for a patron of discerning taste. Lieutaud
used only straight lines to construct the simple and
elegant case and veneered it with precious, exotic
woods such as tulipwood, kingwood, and ama-
ranth. An early proponent of neoclassicism,
Caffiéri designed the gilt bronzes in the purest
neoclassical style with ornamental elements drawn
from classical architecture and subjects from
classical mythology. The sculptural group at the
apex of the clock represents Apollo driving his
chariot on his daily journey across the sky.

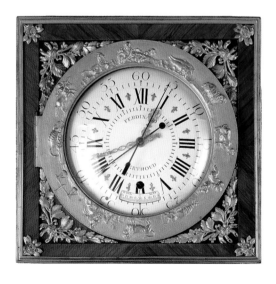

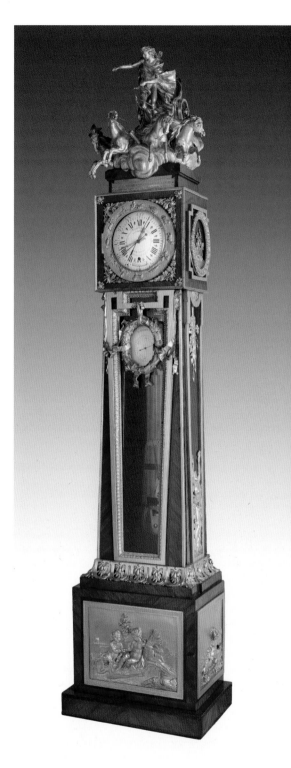

Clock

FERDINAND BERTHOUD
French, Paris, ca. 1770
Gilt bronze
16¼ × 26¼ × 7⅞ in. (41.3 × 66.7 × 20 cm)
Henry Clay Frick Bequest (1916.6.14)

An exact model of this clock—but with a movement by Charles Athanase Pinon (now at the Château de Versailles on long-term loan from the Mobilier National)—was delivered in 1773 to the apartment of the Count of Artois, brother of Louis XVI, at the Château de Versailles. The clock's sculptural elements representing the Triumph of Love over Time were adapted specifically to match the theme of the young prince's apartment: gallant conquests. The present clock was probably made shortly after, with a movement by the celebrated Ferdinand Berthoud, appointed clockmaker to the king in 1773. Its provenance is unknown.

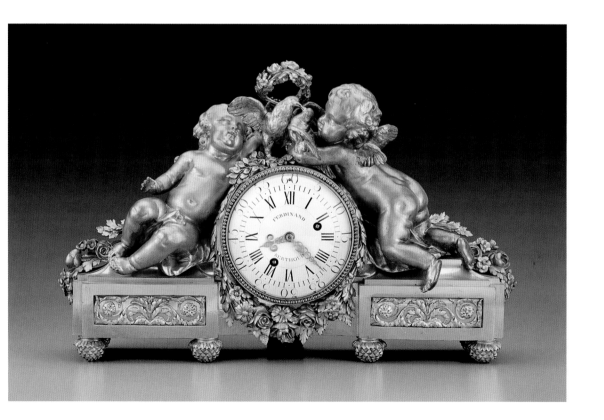

Regulator Clock Showing Mean and Solar Time

MOVEMENT BY ROBERT ROBIN

CASE ATTRIBUTED TO PIERRE-PHILIPPE THOMIRE

ENAMELING BY JOSEPH COTEAU

MAINSPRING BY CLAUDE MONGINOT

French, Paris, 1784

Gilt brass, steel, polychrome enamel and gold on gilt brass and bronze

16⅛ × 8¾ × 6 ¹³⁄₁₆ in. (41 × 22.3 × 17.3 cm)

Bequest of Winthrop Kellogg Edey, 1999 (1999.5.151)

Solar time (the time determined by a sundial) and mean time (the time shown on a clock) agree only four times a year and can vary by as much as sixteen minutes. The difference between these two times is known as the equation time. This "equation" clock automatically adjusts the relationship of the two minute hands throughout the course of the year. When the gilt-brass minute hand is adjusted to the time shown on a sundial, the blued-steel minute hand will automatically indicate the correct mean time. One of the finest French clockmakers of the eighteenth-century, Robert Robin received several royal appointments during the reign of Louis XVI. This elegant design, which he introduced around 1780, was his most successful model.

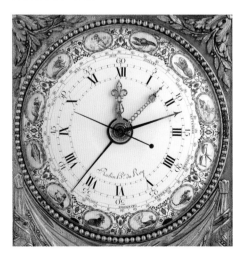

Regulator Clock Showing Mean and Solar Time

MOVEMENT BY ROBERT ROBIN

CASE ATTRIBUTED TO PIERRE–PHILIPPE THOMIRE

ENAMELING BY JOSEPH COTEAU

MAINSPRING BY CLAUDE MONGINOT

French, Paris, 1792

Gilt brass, steel, polychrome enamel and gold on gilt brass and bronze

16⅛ × 9⅜ × 7⅝ in. (42.2 × 23.8 × 19.4 cm)

Bequest of Winthrop Kellogg Edey, 1999 (1999.5.150)

The inventory of the Château de Saint-Cloud made in January 1794 features two clocks in Marie-Antoinette's *pièce des nobles* (room for receiving visiting nobility) that were not there during the previous inventory of 1789. One of them is probably the present example made by Robert Robin, clockmaker to the king, who signed the dial. However, the queen probably never saw this clock as she was not permitted to visit her castle after 1791. Around 1860, the clock was still, or again, at Saint-Cloud, in the bedroom of Empress Eugénie, who surrounded herself with objects that belonged, or were thought to have belonged, to Marie-Antoinette.

The Dance of Time Clock

MOVEMENT BY JEAN-BAPTISTE LEPAUTE
SCULPTURE BY CLAUDE MICHEL CLODION
French, Paris, 1788
Terracotta, brass, gilt brass, silvered brass, steel,
and glass
Sculpture: 21⅛ × 12¾ × 8¼ in. (54.3 × 32.4 × 21 cm)
Globe: diam. 10¹⁵⁄₁₆ in. (27.5 cm)
Purchased by The Frick Collection through the
Bequest of Winthrop Kellogg Edey, 2006 (2006.2.02)

Jean-Baptiste Lepaute, clockmaker to Louis XVI,
worked in close collaboration with Claude
Michel Clodion, one of the most inventive and
technically gifted sculptors of his time, to create
this unique clock. Clodion was trained in Rome,
where he studied classical art. Here, he sculpted
three semi-draped nymphs dancing around a
column, perhaps the three Horae (hours), who
personify the passage of time in Greek mythology.
They support Lepaute's complex pendulum
clock with a rotating annual dial meant to be
admired through a transparent glass globe.
Lepaute and Clodion created this extraordinary
piece for its first owner, the architect Alexandre-
Théodore Brongniart.

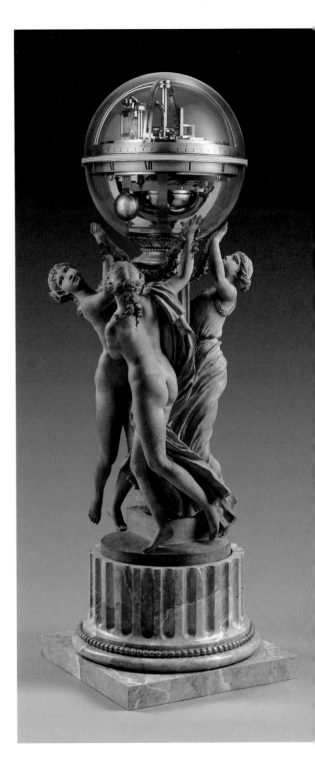

Double-Dial Watch Showing Decimal and Traditional Time

ABRAHAM-LOUIS BREGUET AND
ANTOINE-LOUIS BREGUET
French, Paris, ca. 1795–after 1807
Gold, enamel, gilt brass, brass, and steel
H. ¹⁵⁄₁₆ in. (2 cm), diam. 2⅞ in. (7.3 cm)
Bequest of Winthrop Kellogg Edey, 1999 (1999.5.154)

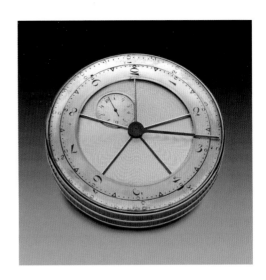

At the end of the eighteenth and the beginning of
the nineteenth century, the innovative horologist
Abraham-Louis Breguet and his son, Antoine-
Louis, created highly accurate movements set in
restrained, elegant cases. The elder Breguet's
combination of technical skill, refined design, and
exquisite craftsmanship earned him an unrivaled
reputation. His patrons included Louis XVI,
Napoleon, and most of the civil servants and
political leaders of his day. This double-dial desk
watch is one of the very few timekeepers that
includes both traditional and decimal dials. The
decimal system, introduced during the French
Revolution, was used not only for weights and
measures but also for time. Decimal time divided
the day into ten hours and the year into ten months.
The decimalization of divisions of the day was
established in November 1793, but as it was
unpractical, it lasted only eighteen months. This
watch, known in Breguet's books as a *garde-temps*
(precision timekeeper), was probably made in the
spring of 1795. It was sold in 1797 to the celebrated
French aristocrat Antoine-César Praslin, Duke of
Choiseul. The present twelve-hour dial was added
after 1807, when Breguet's son joined the business.

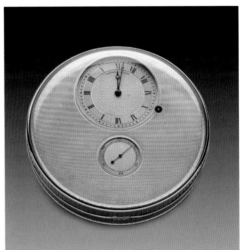

Carriage Clock with Calendar

ABRAHAM-LOUIS BREGUET AND
ANTOINE-LOUIS BREGUET
French, Paris, 1811
Gilt bronze, silver, and enamel
4⅜ × 5⁵⁄₁₆ × 2⁷⁄₁₆ in. (11.1 × 13.4 × 6.3 cm)
Bequest of Winthrop Kellogg Edey, 1999 (1999.5.152)

Invented around 1798 by Abraham-Louis Breguet, carriage clocks were designed to provide all the time-related information a traveler might need during a long journey. The dial indicates the age and phase of the moon, the day, date, month, and year. When it is too dark to see the dial, the button at the top of the case can be pushed down to make the clock strike the time to the last quarter hour. There is also an alarm, which is set for the number of hours of sleep rather than the time of rising.

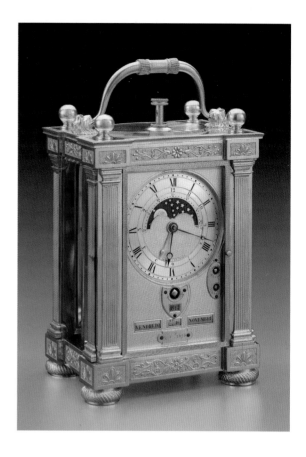

Watch with Tourbillon

ABRAHAM-LOUIS BREGUET AND
ANTOINE-LOUIS BREGUET
French, Paris, ca. 1820
Gold, gilt brass, and steel
3⅛ × 2⁵⁄₁₆ × 2⅝ in. (8 × 5.9 × 6.7 cm)
Bequest of Winthrop Kellogg Edey, 1999 (1999.6.28)

Mechanical watches did not generally keep time
as well as clocks because they were subject to
constant movement, and unless their balance was
perfectly poised, their performance varied when
they were held in different positions. To eliminate
this problem, Abraham-Louis Breguet invented
the *tourbillon* (literally, whirlwind), a device that
mounted the escapement and balance on a small
carriage that averaged out the errors by rotating at
regular intervals.

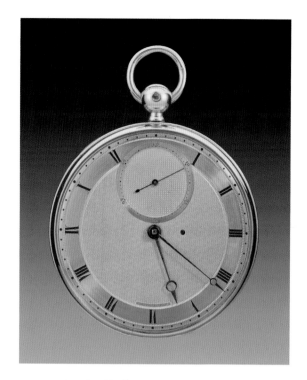

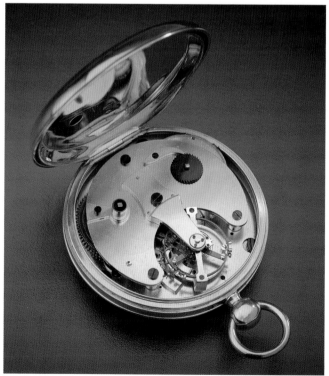

Furniture

Long Center Table

Italian, Lombardy (?), first half of the sixteenth century, with later alterations, additions, and restorations

Walnut

33⅛ × 85¼ × 50 in. (84.1 × 217.8 × 127 cm)

Henry Clay Frick Bequest (1915.5.83)

The Italian origin of this table is confirmed by the carved coats of arms of the Giovanelli and Giovanelli de Noris families of Milan and Venice, respectively. However, its massive size, the use of square pillars and a longitudinal colonnade, and the animal masks at the ends of the feet are more typical of French furniture of the period (see the draw-top center table on p. 78). This suggests that the French military incursions of the early sixteenth century resulted in French influence on northern Italian decorative arts.

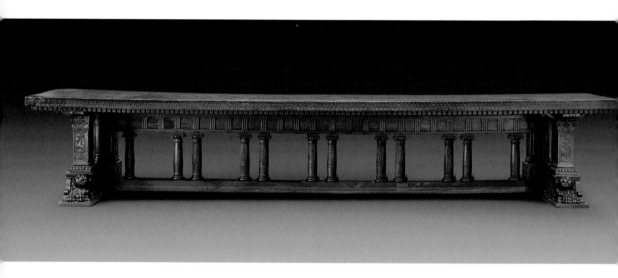

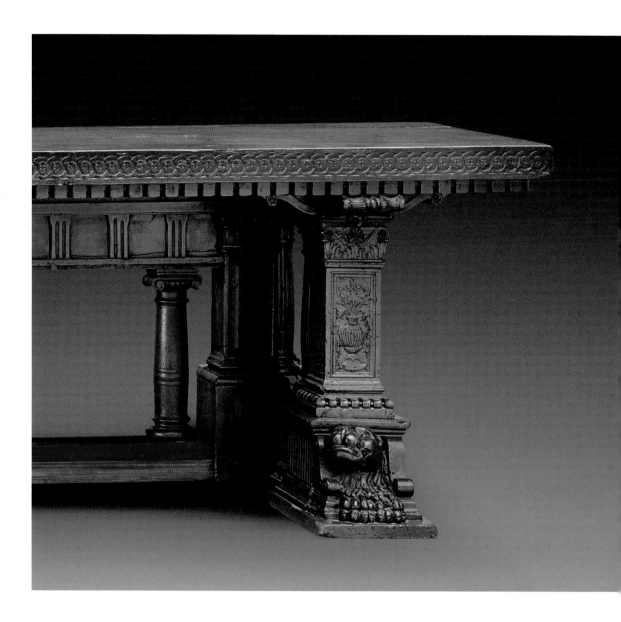

Pair of Chests (cassoni)

Italian, Rome (?), third quarter of the sixteenth century,
with nineteenth-century alterations, additions, and
restorations
Walnut
1916.5.80: 28½ × 66½ × 23¼ in. (72.4 × 168.9 × 59.1 cm)
1916.5.81: 28 × 65½ × 23¼ in. (71.1 × 166.4 × 59.1 cm)
Henry Clay Frick Bequest (1916.5.80–81)

A cassone, or decorated marriage chest, was
considered the most important piece of furniture
in fifteenth- and sixteenth-century Italy. Commis-
sioned especially for the occasion, cassoni were
decorated with a central coat of arms and often
made in pairs.

Typically filled with the gifts the bride received
from her parents, cassoni featured prominently in
wedding festivities, particularly in the public
ceremonial procession from the bride's residence
to her new home. Often displayed together, the
cassoni symbolized the two families' wealth and
newly formed bond. These two examples are
decorated with carved ornaments illustrating
episodes from the life of Apollo, the god of sun and
music, as depicted in Ovid's *Metamorphoses*. The
scene on the top chest illustrates Apollo watching
the nymph Daphne, who chooses to turn into a
tree rather than succumb to the young god's
advances (see detail). To the right of the coats of
arms of the Roberti of Rome, Apollo plays a
fiddle-like instrument called a *lira da braccio*
among wild animals, including a camel and a lion.
The pendant is also decorated with two scenes on
either side of an unidentified coat of arms. The
scene on the left shows the satyr Marsyas chal-
lenging Apollo to a contest of music, which he
would lose. The story continues on the right with
Marsyas being flayed alive for having the arro-
gance to challenge a god.

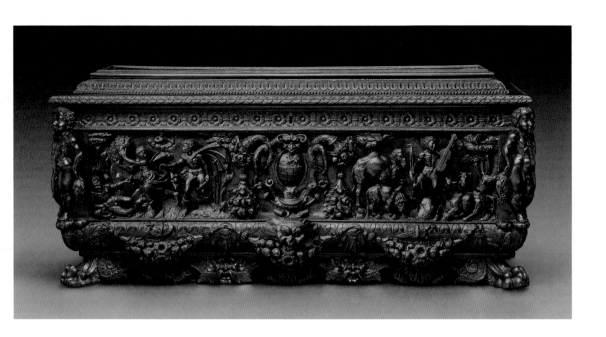

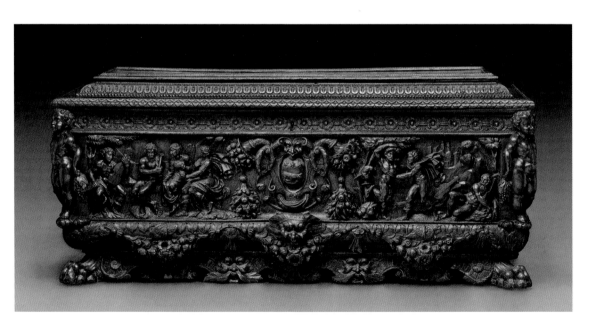

Pair of Chests (cassoni)

Italian, Milan (?), third quarter of the sixteenth century, with nineteenth-century alterations, additions, and restorations
Walnut
1918.5.78: 27¾ × 70⅞ × 21½ in. (70.5 × 180 × 54.6 cm)
1918.5.79: 28½ × 70½ × 21¼ in. (72.4 × 179 × 54 cm)
Henry Clay Frick Bequest (1918.5.78–79)

Like the previous cassoni, these two chests exemplify the art of wooden sculpture in late sixteenth-century Italy. The complex friezes depict scenes from the life of Julius Caesar, as described by Plutarch, the Greek historian and biographer. On the top chest, the scene at right represents Caesar returning victorious to Rome after a long war. Three captives march behind the horses drawing his chariot. The scene at left shows a similar chariot, filled with booty and drawn by four horses (see detail). On the other chest, the scene at left depicts Caesar in armor at the center facing right, directing the opening of the treasury. In the scene to the right of the coats of arms of the Crivelli of Milan, eight figures gather before a statue of a warrior.

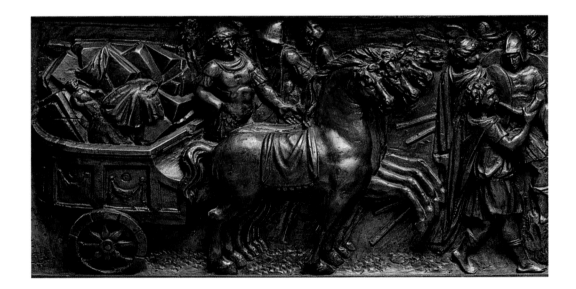

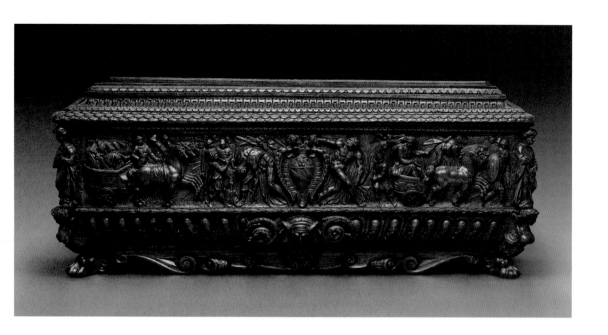

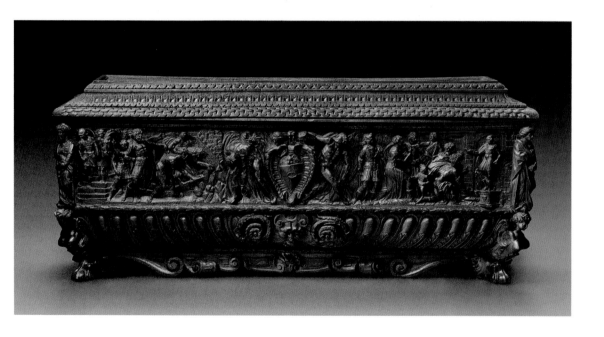

Draw-Top Center Table

French, second half of the sixteenth century,
with nineteenth-century restorations
Walnut
34¾ × 116¾ × 34½ in. (88.3 × 296.5 × 87.6 cm)
Henry Clay Frick Bequest (1916.5.84)

In the second half of the nineteenth century, this table, as well as the dressoir on the following page, belonged to the French collector Maurice Chabrières-Arlès, who amassed an important collection of decorative arts, celebrated above all for its sixteenth-century French furniture. Chabrières-Arlès acquired this table from Louis Carrand, the son of the collector, dealer, and restorer Jean-Baptiste Carrand, principal adviser to the Russian collector Peter Soltykoff. The table has been heavily restored, probably by Carrand, but has many carved and construction details that suggest a sixteenth-century origin. This table is related to a small group of French Renaissance tables, including one in the collection of the Louvre Museum, that incorporate architectural elements such as consoles, columns, balusters, and arcades in their design. It is unclear whether the model originated in France or Italy, as artistic exchange between the two countries was frequent at the time, but this particular piece seems to have been inspired by prints by the French architect, designer, and engraver Jacques Androuet du

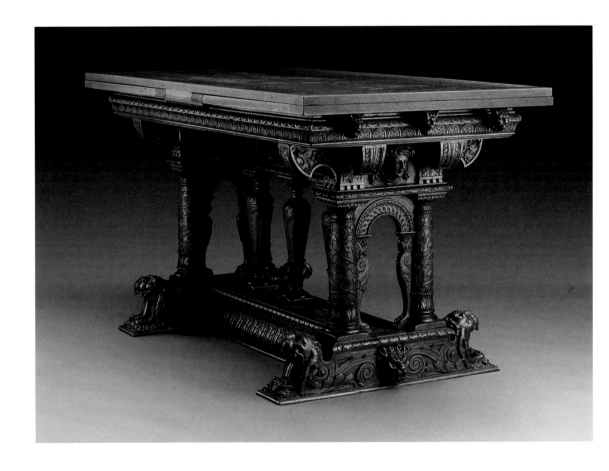

Dressoir

French, probably Lyon, ca. 1575, with nineteenth-century
alterations, additions, and restorations
Walnut and beech
63 × 69⅜ × 22½ in. (160 × 176.9 × 57.1 cm)
Henry Clay Frick Bequest (1916.5.86)

Dressoirs (cabinets with two doors and three
drawers supported by a stand) were used to store a
household's most valuable tableware. Thoroughly
restored in 1855 in Marseille, France, this finely
carved dressoir offers a compendium of the
decorative elements commonly used in French
Renaissance art, including satyrs, harpies, female
terms (or terminal figures), masks, and strapwork
(decorative straplike bands). First emerging in the
1530s and 1540s at the court of Francis I at
Fontainebleau, this style became increasingly
playful in the hands of subsequent generations of
craftsmen, as demonstrated by this piece.

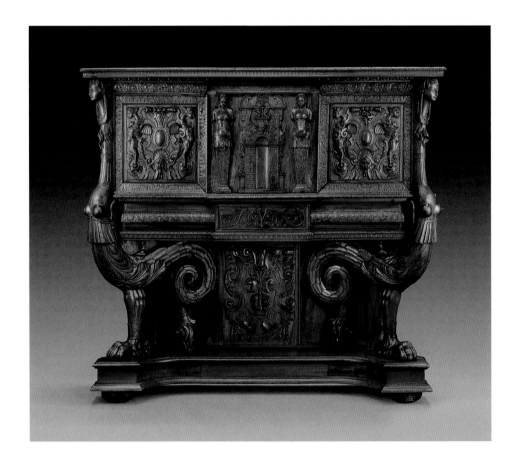

Pair of Octagonal Pedestals

ATTRIBUTED TO ANDRÉ-CHARLES BOULLE
French, Paris, after 1686–1715, with possible late
eighteenth-century modifications
Fir veneered with turtle shell, brass, ebony, and
ebonized fruitwood; gilt bronze
Each, 45 × 22½ × 22½ in. (114.3 × 57.1 × 57.1 cm)
Henry Clay Frick Bequest (1916.5.06–07)

Often created in pairs, octagonal pedestals of this
size were made to support large pieces of sculp-
ture or Chinese porcelain. They were intended to
stand away from the wall and be seen in the
round. The eight-sided model derives from a pair
of pedestals made in 1686 by André-Charles
Boulle, the celebrated cabinetmaker to Louis XIV,
for the king's oldest son, the Grand Dauphin. These
are now kept at the Chaalis Abbey, north of Paris. It
is not known who commissioned this pair, but they
were probably made by Boulle before 1715, when
he turned his workshop over to his sons. The base,
cornice, and top were likely altered later in the
century to suit the taste of their new owner.

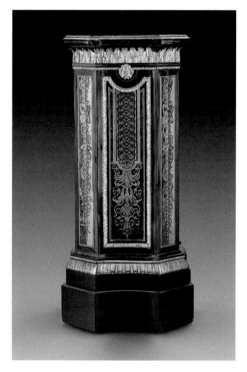
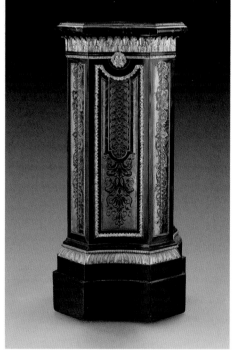

Kneehole Desk

ANDRÉ-CHARLES BOULLE AND
ETIENNE LEVASSEUR
French, Paris, ca. 1692–95, with later alterations
ca. 1770 (before 1777)
Oak, fir, and walnut veneered with brass, turtle shell,
and ebony; gilt bronze, leather
30¾ × 57⅞ × 29⅛ in. (78.1 × 147 × 74 cm)
Henry Clay Frick Bequest (1918.5.101)

Originally, this desk was twenty inches longer and
five inches deeper, and its eight legs were linked
with stretchers (four together on each side).
André-Charles Boulle invented the model in the
early 1690s, producing only a few pieces with
turtle shell and brass marquetry. The decorative
pattern here—in turtle shell with brass back-
ground—is known as *contre-partie* marquetry.
Boulle's furniture continued to be appreciated
throughout the eighteenth century. In the early
1770s, the cabinetmaker Etienne Levasseur
modified the desk for its new owner, probably the
famous art dealer Claude Julliot, who owned the
altered version by 1777. The alteration included
cutting the marquetry panels, therefore removing
an important part of Boulle's work. However,
Levasseur retained Boulle's large gilt-bronze
mounts in the shape of Indian heads.

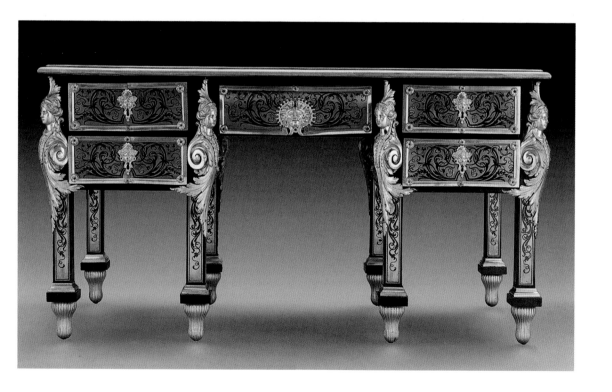

Writing Table

ANDRÉ-CHARLES BOULLE

French, Paris, ca. 1710, with later alterations
Oak and walnut veneered with brass, turtle shell,
ebony, and pewter; gilt bronze, leather
31¾ × 74¼ × 36⅞ in. (80.6 × 188.6 × 93.7 cm)
Henry Clay Frick Bequest (1916.5.01)

The late seventeenth century saw the emergence
of new types of furniture, many created by
André-Charles Boulle. Boulle most likely invented
the *bureau plat* (flat writing table), as it is known
today. Previously, writing tables had been supported
by eight legs and had several drawers on each side
(see the desk on p. 81). But around 1710, Boulle
simplified the design by eliminating the drawers
and reducing the number of legs to four. He also
gave an elegant curve to the once-straight legs.

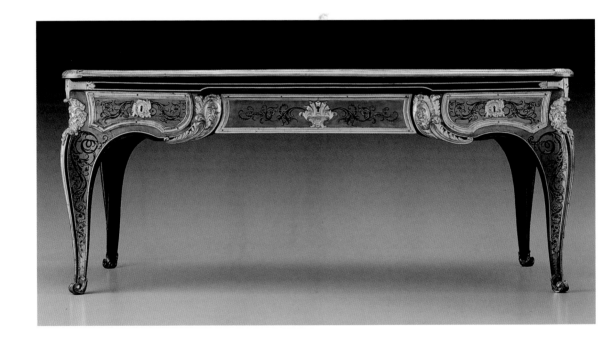

Commode

ATTRIBUTED TO ANDRÉ-CHARLES BOULLE

French, Paris, ca. 1710, with later alterations
Oak and walnut veneered with kingwood and tulip-
wood; gilt bronze, marble
34½ × 66¾ × 24 in. (87.6 × 167 × 61 cm)
Henry Clay Frick Bequest (1915.5.127)

Originally, this commode was almost certainly
covered with panels of turtle shell and brass
marquetry. Considering the fragility of Boulle
marquetry, it is likely that the original panels
deteriorated beyond repair and were replaced by
the current wood marquetry veneer. The commode
retains its early eighteenth-century shape, which is
similar to a drawing attributed to André-Charles

Boulle now at the Musée des Arts Décoratifs, Paris.
The designs and quality of the chased and gilt-
bronze mounts are also characteristic of the work of
the celebrated cabinetmaker to Louis XIV and date
from the early eighteenth century.

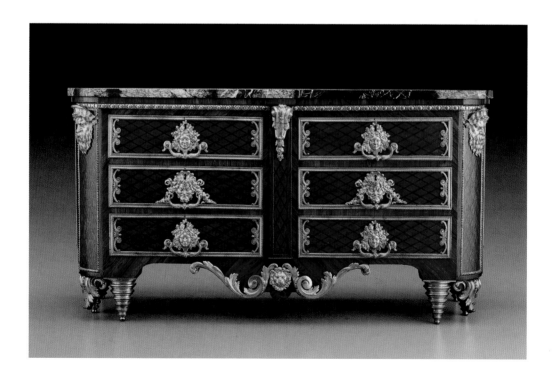

Commode (one of a pair)

WILLIAM BLAKE AFTER
ANDRÉ-CHARLES BOULLE
English, London, ca. 1820–50
Oak and walnut veneered with turtle shell, brass, and
ebony; gilt bronze, marble
Each, 34¾ × 48¾ × 25¼ in. (88.3 × 123.8 × 64.2 cm)
Henry Clay Frick Bequest (1916.5.02–03)

André-Charles Boulle's furniture was sought after,
restored, and copied throughout the eighteenth and
nineteenth centuries in France and abroad. Around
1850, the London firm Blake produced these two
copies of one of Boulle's most celebrated pieces, a
pair of commodes made in 1708–9 for Louis XIV at
the Grand Trianon in the garden of Versailles. In the
1820s, a certain Robert Blake was known in London
as a "Buhl [Boulle] manufacturer and cabinet
inlayer." He seems to have retired or died by 1843,
when he was succeeded by his sons (one of whom
was William), also known as "Buhl & marquetry
furniture & inlaid flooring manufacturers." In 1916,
Henry Clay Frick purchased these two pieces "not
guaranteed of the period" from the art dealer
Joseph Duveen for a mere $15,000.

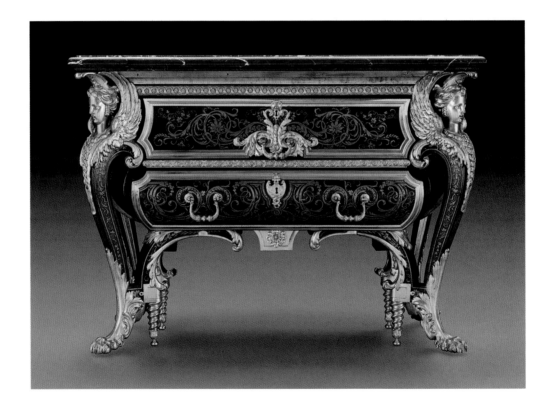

Console Table

French, probably Provence or Comtat Venaissin,
1730–35
Iron and marble
35½ × 51¼ × 25 in. (90.1 × 130.1 × 63.5 cm)
Henry Clay Frick Bequest (1914.5.32)

Little is known about eighteenth-century forged-iron furniture beyond its having been made by metalsmiths who forged interior and outdoor balustrades, balconies, fences, and gates. The art of ironwork flourished in Paris and many other cities and towns throughout France. This table is similar to a few others made in southeastern France, more precisely in Provence and in the Comtat Venaissin, the region around the city of Avignon, where a tradition of fine ironwork dates to the Middle Ages. Not necessarily made for the outdoors, these tables primarily furnished vestibules, salons, and dining rooms. This rare example combines fine forged iron and gilt repoussé iron—where the metal is ornamented and shaped by hammering from the reverse side.

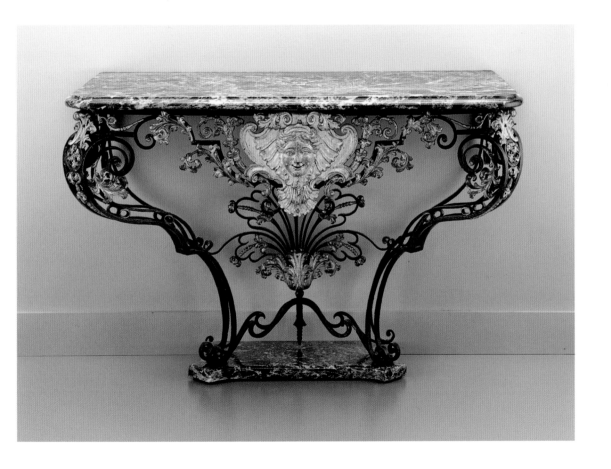

Armchairs (two of eight)

Frames: probably French, ca. 1730–50; walnut

Covers: probably French or Netherlandish, ca. 1750–70; wool and silk

Frames (average): 41¼ × 28⅜ × 32¼ in. (104.8 × 72.1 × 81.9 cm)

Covers (average): backs, 26½ × 23¼ in. (67.4 × 50.1 cm); seats, 28⅜ × 29¼ in. (72 × 74.4 cm)

Henry Clay Frick Bequest (1910.5.24–31)

The origin and date of production of these unusual chairs are uncertain, but the style and quality of the carved wood frames suggest they were made in Paris around 1730 or in a French province ten to fifteen years later. On the other hand, the tapestries feature shadows cast by the bouquets on the ground color, a highly original refinement that appeared only in the late 1760s at the French Royal tapestry manufactory of the Gobelins and earlier in tapestries produced in the Netherlands. The latter origin is supported by the composition of bouquets of flowers and fruits with insects, birds, and small animals (dragonfly, moth, snail, and parrot) more common in the Netherlands than in France. The frames and tapestry covers may have been assembled at a later date.

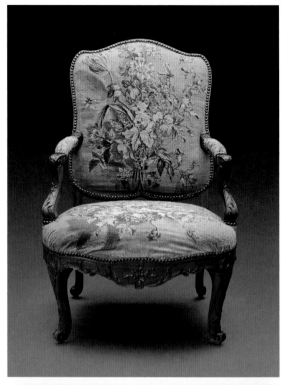

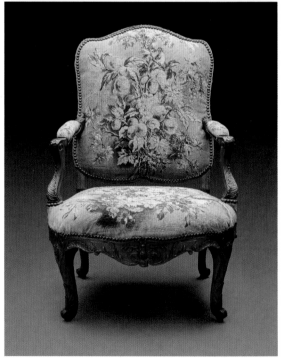

Sofa and Armchairs (from a seven-piece set)

Frames: French, Paris, ca. 1760 by Nicolas Heurtaut; walnut, gilt and painted

Covers: French, Beauvais Tapestry Manufactory, 1765; wool and silk

Large sofa frame: 37⅛ × 52⅝ × 29⅜ in. (94.3 × 133.6 × 74.6 cm)

Small sofa frames (average): 36⅞ × 40⅝ × 29½ in. (93.7 × 103.3 × 75 cm)

Armchair frames (average): 36¼ × 26¼ × 27 in. (92.1 × 66.7 × 68.6 cm)

Large sofa covers: back, 21¾ × 45¼ in. (55.3 × 114.9 cm); seat, 27½ × 57 in. (69.9 × 144.8 cm)

Small sofa covers: backs, 22 × 34½ in. (55.9 × 87.6 cm); seats, 27 × 44 in. (68.6 × 111.8 cm)

Armchair covers (average): backs, 20¾ × 18¾ in. (52.6 × 47.7 cm); seats, 26½ × 30 in. (67.3 × 76.2 cm)

Henry Clay Frick Bequest (1918.5.47–53)

This is a rare example of a set of seating furniture with its tapestries upholstered to their original frames. The frames were made around 1760 by the Parisian chairmaker and woodcarver Nicolas Heurtaut for his client François de Bussy, an aristocrat and courtier. The tapestry covers were woven for de Bussy at the Beauvais Tapestry Manufactory in 1765. The backs were woven after designs by François Boucher, and at least three of the seats are after compositions by Jean-Baptiste Oudry. Originally, the wooden frames were entirely gilded. They were most likely regilded and painted in the late nineteenth century, when they were owned by Baron Maurice de Rothschild.

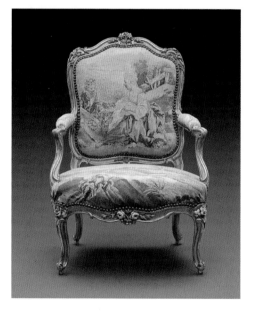

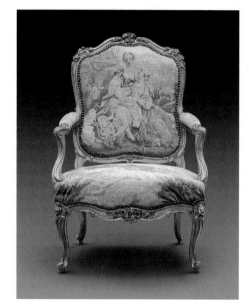

Pair of Cabinets

BERNARD VAN RISENBURGH II AND III
French, Paris, ca. 1764
Oak with veneered ebony, tulipwood, amaranth,
and padouk; lacquer, gilt bronze, marble
Each, 35¼ × 47¼ × 22 in. (89.6 × 120 × 55.9 cm)
Henry Clay Frick Bequest (1918.5.42–43)

These two cabinets may well be the last pieces of
furniture made by the celebrated Parisian
cabinetmaker Bernard van Risenburgh II just
before he retired in 1764 and sold his workshop to
his son, Bernard van Risenburgh III, who finished
them. The cabinets feature eight panels of black-
and-gold Japanese lacquers of exceptionally high
quality taken from a seventeenth-century Japanese
cabinet, chest, or screen. Beginning in the 1730s,
the older van Risenburgh worked almost exclusively
with the influential *marchands-merciers* (merchants
of luxury goods), who provided the cabinetmaker
with the rare and costly Oriental lacquers and
sometimes with the design for the furniture on
which to mount them.

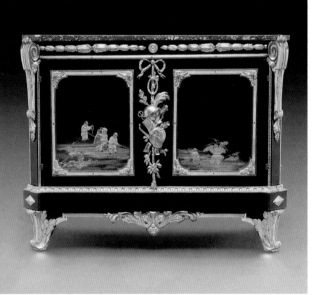
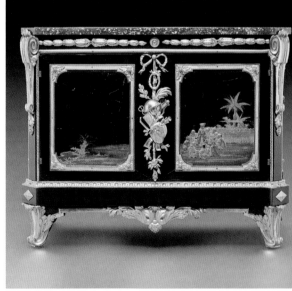

Commode

ROGER VANDERCRUSE LACROIX UNDER THE
DIRECTION OF GILLES JOUBERT
French, Paris, 1769
Oak veneered with various woods including maple,
pearwood, bloodwood, and amaranth; gilt bronze,
marble
35¼ × 73½ × 26½ in. (90.8 × 186.7 × 66.1 cm)
Henry Clay Frick Bequest (1915.5.37)

This commode was made for the bedroom of
Madame Victoire, daughter of Louis XV, at the
Château de Compiègne, where it was placed under
a large pier mirror, opposite the fireplace. Depicting
trophies, vases, and urns filled with flowers, the
marquetry panels were meant to echo the princess's
bed hangings, curtains, and seating covers made of
a taffeta chiné (a warp-printed taffeta) with "new
patterns of flowerpots." The colors of the fabric—
green, gray, and yellow—were repeated on the
commode, whose marquetry panels were stained
with natural dyes that have almost completely
disappeared. Archival documents attest that Gilles
Joubert, cabinetmaker to the king in 1763, delivered
this commode to the court. However, the furnishing
of royal residences demanded more furniture than
the elderly craftsman could provide, and Joubert
often subcontracted work to other cabinetmakers,
including Roger Vandercruse Lacroix, whose
stamp, R.V.L.C., is found in four different places on
this commode. Lacroix's workshop was responsible
for the woodwork while an unknown bronze maker
designed, cast, and chased the gilt-bronze mounts.

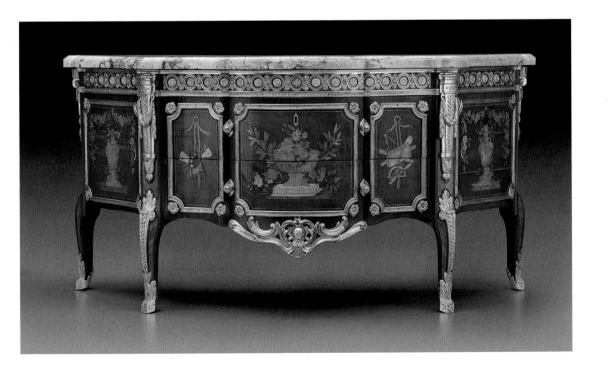

Mechanical Table

MARTIN CARLIN

French, Paris, ca. 1770–75

Oak veneered with holly, ebony, maple, amaranth, tulipwood, and satinwood; gilt bronze and marble

31⅞ × 27⅞ × 15⅞ in. (81 × 70.8 × 40.3 cm)

Henry Clay Frick Bequest (1914.5.67)

Often done in the presence of friends and visitors, dressing and grooming were important activities in the life of an eighteenth-century aristocratic lady and called for many accessories and pieces of furniture designed especially for primping. This small dressing table features a mirror and compartments on either side to store toilet articles, as well as a book rest (the back of the mirror), a shallow drawer to keep sheets of paper, and two small storage compartments for quills and inkpots, should it become necessary to write a short note while getting ready for the day. Finally, the upper section can be removed and placed elsewhere—perhaps on a bed—where it can rest on its four short feet. The lower section then becomes a table complete with the compartments and drawers to store the accessories needed for getting dressed, writing, and eating a light meal, as usually happened during this daily ceremony.

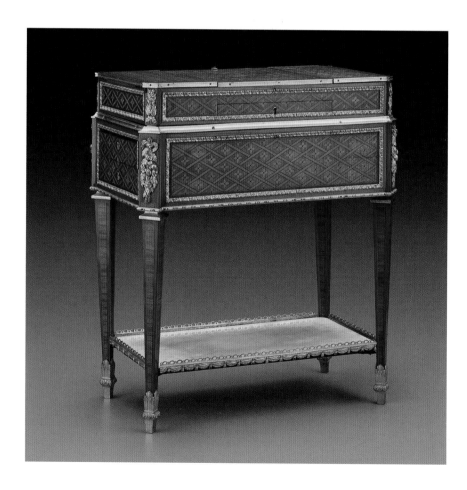

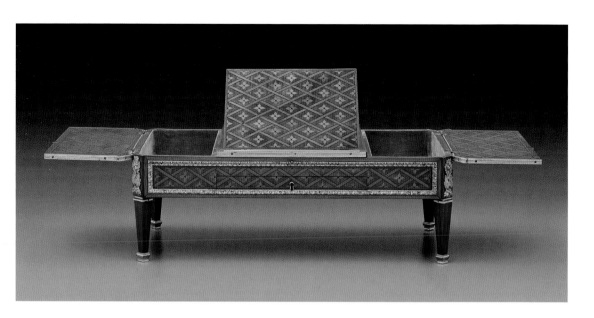

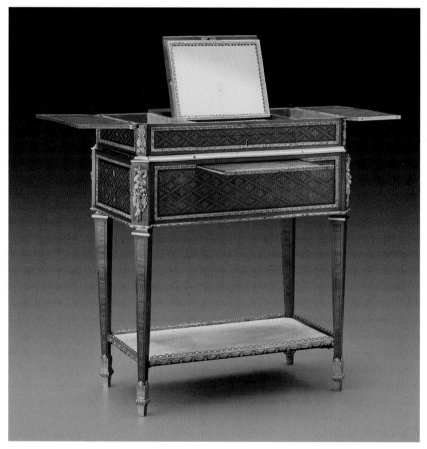

Mechanical Table

MARTIN CARLIN

French, Paris, ca. 1780

Oak veneered with maple; plaques of soft-paste
porcelain; gilt bronze and marble

45¾ × 14⅛ × 10¾ in. (116.2 × 35.9 × 27.3 cm)

Henry Clay Frick Bequest (1915.5.62)

This delicate table, probably made for a fashionable
lady, reflects the French fascination with mechani-
cal devices during the second half of the eighteenth
century. Brass supports hidden inside the upper
portion of each of the legs allow the tabletop to be
raised an additional fifteen inches. A system of
concealed cogwheels connects the four supports
and allows the top to be lifted with little effort. The
top also pivots and tilts; and on each side, small
wooden boards extend, possibly to hold candle-
sticks. It is unlikely that this table was used to
support more than a small cup of tea or chocolate.
The various mechanical devices are difficult to
engage, suggesting that this piece was activated
only on rare occasions for a discerning audience.

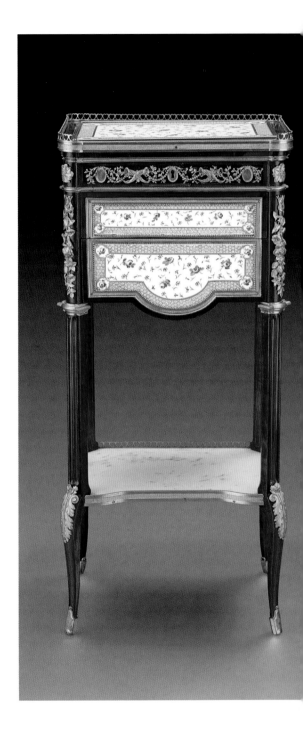

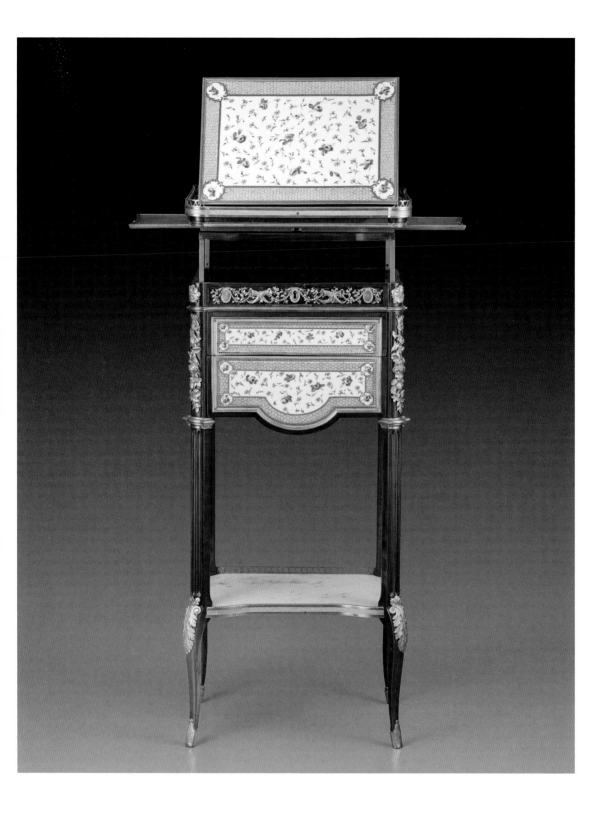

Tripod Table

French, Paris, ca. 1783
Gilt bronze, oak, and Sèvres soft-paste porcelain
H. 29½ in. (74.9 cm), diam. 14⅝ in. (37.1 cm)
Henry Clay Frick Bequest (1918.5.61)

Furniture incorporating Sèvres porcelain plaques
was particularly fashionable in Paris in the second
half of the eighteenth century. This table was
probably designed and sold by the period's leading
marchands-merciers, the partners Simon-Philippe
Poirier and Dominique Daguerre, who received
exclusive rights from the Sèvres Porcelain Manu-
factory to commission porcelain plaques that could
be used on furniture. Painted with colorful cut
flowers, probably by Edmé-François Bouilliat, the
table's two circular plaques are among the finest
produced at Sèvres in the early 1780s. The lower
plaque bears the mark of the gilder Michel-Barnabé
Chauvaux (known as Chauvaux *aîné*), who painted
the tooled gold borders on the plaques.

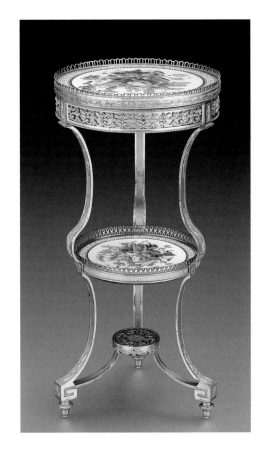

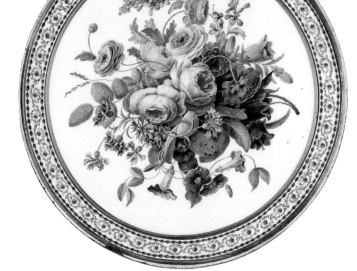

Console Table (one of a pair)

French, Paris, ca. 1780
Beech, walnut, and marble
Each, 34⅛ × 34¾ × 9½ in. (86.7 × 88.3 × 24.1 cm)
Henry Clay Frick Bequest (1914.5.69–70)

The early history of these small console tables is unknown, but their exceptional quality and highly original design suggest a prestigious origin. There is little doubt that they were commissioned for a room decorated with a Turkish theme, as every element evokes the Ottoman Empire. The crossed crescents at the top of the tables are a traditional symbol of Turkey while the supporting figures depicting African youths wearing turbans probably depict African slaves or the eunuchs who administered the Ottoman court harem. The legendary Ottoman Empire is alluded to in the central medallions, which feature the profiles of a sultan and a woman in low relief. One medallion represents Beyazid I surrounded by the inscription MUSULMAN IMPERATOR ANNO M.CD.II, which translates as "Muslim emperor, year 1402." In 1402, Beyazid I was captured by the great Tartar conqueror Timur during the battle of Angora.

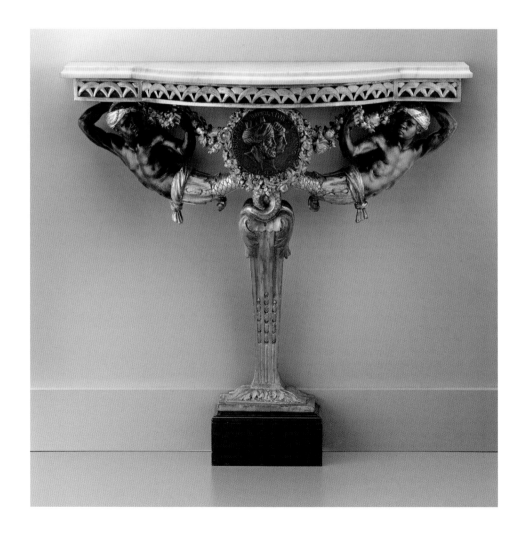

Secretaire and Commode

JEAN-HENRI RIESENER

French, Paris, ca. 1780 and 1790 (secretaire), 1791
(commode)

Oak veneered with various woods including ash,
bloodwood, and amaranth; gilt bronze, leather, marble

Secretaire: 56⅛ × 45½ × 17¼ in. (143.2 × 115.6 × 43.8 cm)

Commode: 37¾ × 56¾ × 24⅝ in. (95.9 × 144.2 × 62.6 cm)

Henry Clay Frick Bequest (1915.5.75–76)

Jean-Henri Riesener, one of the eighteenth century's
finest French cabinetmakers, was appointed
ébeniste du roi (cabinetmaker to the king) in 1774,
the year Louis XVI and Marie-Antoinette ascended
to the throne. During the next ten years, Riesener
made numerous pieces of furniture for the royal
family, including the queen, who seems to have
particularly appreciated the cabinetmaker's
imaginative designs and beautifully crafted

furniture. Riesener lost his title in 1784 due to
administrative changes in the Garde-Meuble Royal,
the organization responsible for furnishing the
royal residences, but continued to work for
Marie-Antoinette. In the early 1780s, he delivered
this secretaire and commode for one of the many
residences she was refurnishing, possibly the
Château de Saint-Cloud, west of Paris. Several years
later, Riesener reworked these two pieces for her
new apartment at the Tuileries, where the royal
family was forced to reside after the revolution
began in 1789. This required reducing their scale to
better suit the humbled queen's new abode.
Riesener's creative solution was to shorten each
piece, change the feet, apply simpler mounts, and
add a new marquetry panel on the center of each
piece. He was no doubt pleased with the elegant
results as he took the unusual step of signing and
dating the new marquetry panels.

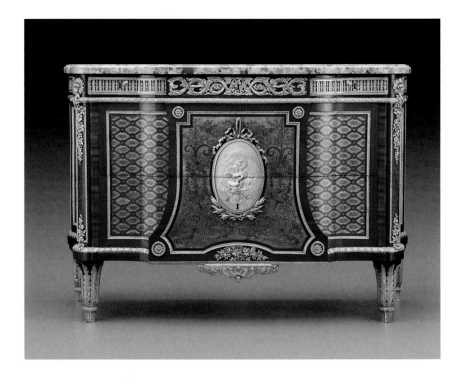

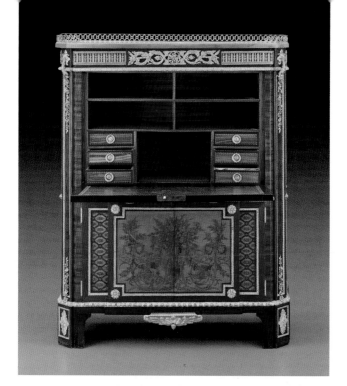

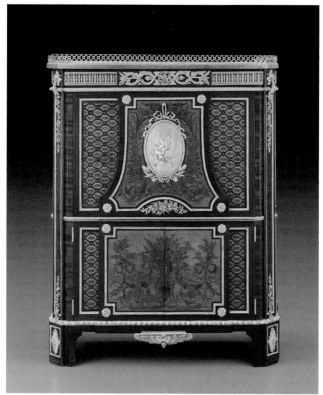

Commode

ATTRIBUTED TO JEAN-HENRI RIESENER
French, Paris, 1785–90
Oak, mahogany, gilt bronze, and marble
38⅛ × 62⅜ × 20¼ in. (96.8 × 158.4 × 52.7 cm)
Henry Clay Frick Bequest (1918.5.71)

This commode and the writing table on the following page are attributed to Jean-Henri Riesener because of the meticulous craftsmanship and the presence of gilt-bronze mounts that are found on other furniture signed by the cabinet-maker. Particularly remarkable is the jewel-like Apollo mask on the frieze (see detail), which ranks among the finest examples of the period. This commode also incorporates Riesener's character-istic drawer construction with a hollow on the bottom's edges. Flanked by curved ends and containing open shelves, this type of commode, of which Riesener made only few, was created in the early 1780s and was probably designed to display prized objects of porcelain or lacquer in a salon or bedroom.

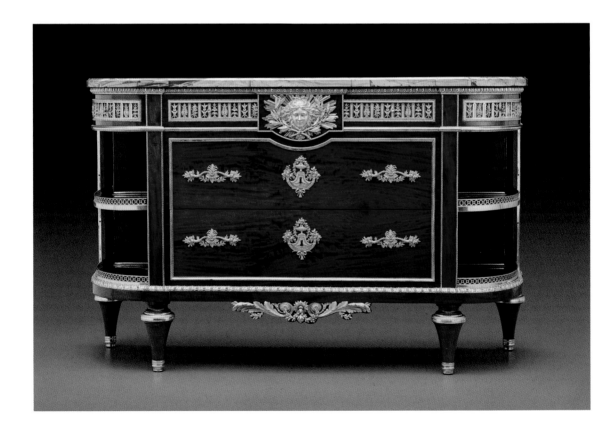

Writing Table

ATTRIBUTED TO JEAN-HENRI RIESENER
French, Paris, 1785–90
Oak, fir, mahogany, gilt bronze, and leather
31¼ × 40⅞ × 23⅞ in. (79.4 × 103.8 × 60.6 cm)
Henry Clay Frick Bequest (1914.5.74)

Small, luxurious writing tables such as this were usually found in the private apartments of an aristocratic residence or chateau, often in a lady's bedroom for her correspondence and reading as they do not offer much space to spread books and documents. This table lacks both the customary drawer for storing paper and the standard fitted *écritoire*, or writing compartment, to keep the ink and quills. It is therefore possible that it was designed to be used in a study, probably by a man, who would have also owned a large matching *bureau plat* (now lost) with ample drawer space and the necessary writing accessories.

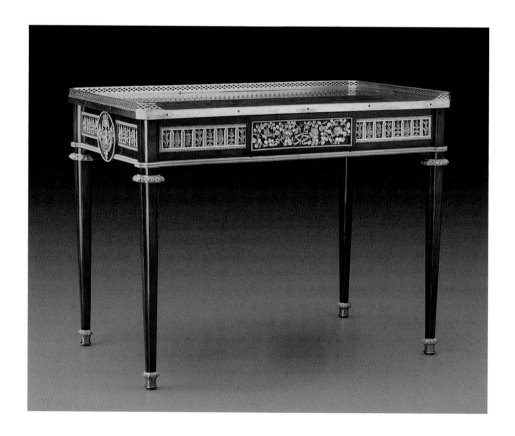

Side Table

BRONZES BY PIERRE GOUTHIÈRE
DESIGNED BY JEAN-FRANÇOIS-THÉRÈSE CHALGRIN
AND FRANÇOIS-JOSEPH BÉLANGER
French, Paris, 1781
Marble and gilt bronze
37½ × 81⅛ × 27 in. (95.3 × 206.1 × 68.6 cm)
Henry Clay Frick Bequest (1915.5.59)

Aristocrats, financiers, and diplomats often owned furnishings more luxurious than those destined for royal settings. Commissioned in the early 1780s by Louise-Jeanne de Durfort, Duchess of Mazarin, this stunning side table is one of the very few pieces of eighteenth-century furniture made entirely in hard stone, in this case, a rare grayish-blue marble from North Africa known in France as *bleu turquin*. The table was the collaborative work of three of the greatest artists active in Paris at the time: its two designers, the architect Jean-François-Thérèse Chalgrin, better known as the architect of the Arc de Triomphe, and François-Joseph Bélanger, architect of the king's brother, the Count of Artois; and the great *ciseleur-doreur* (chaser-gilder) Pierre Gouthière, who modeled, gilt, and chased the neoclassical bronzes with characteristic, unsurpassed technique. Gouthière's extremely detailed chasing lends a naturalistic appearance to the swirling leaves, swags of fruit, and particularly the hair of the central mask (see pp. ii–iii). Credited with pioneering the use of matte gilding on bronze, Gouthière emphasizes the subtle contrast between dull surfaces and areas of glossy gilding, which brings additional depth to the sculptural mounts.

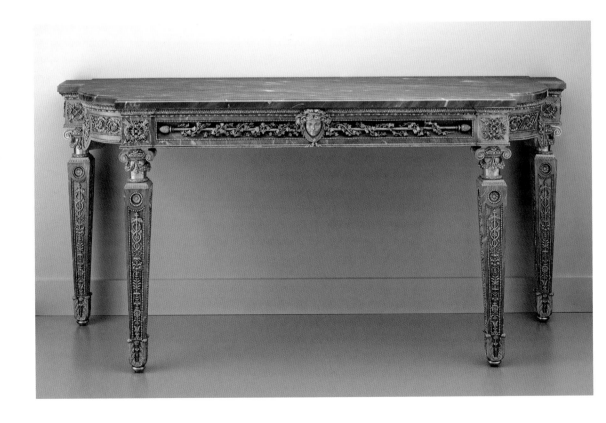

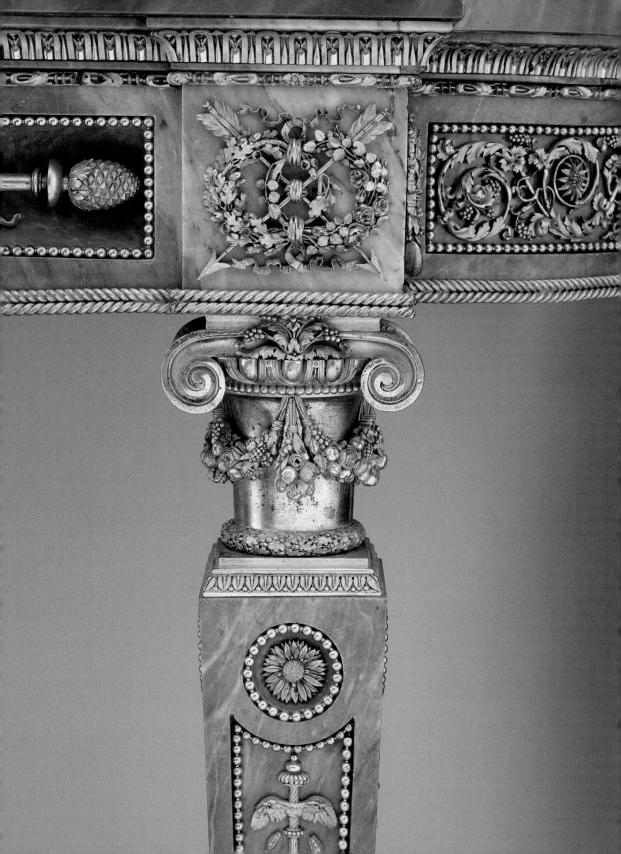

Chimneypiece

DESIGNED BY FRANÇOIS-JOSEPH BÉLANGER
FIGURES MODELED BY JEAN-JOSEPH FOUCOU
French, Paris, 1780–85
Marble and gilt bronze
43⅝ × 72¾ × 20 in. (110.8 × 184.7 × 50.8 cm)
Henry Clay Frick Bequest (1916.11.01)

The prototype of this chimneypiece with two large female satyrs was almost certainly created in *bleu turquin* for Louise-Jeanne de Durfort, Duchess of Mazarin, and placed in her Parisian residence (opposite the side table on p. 102). The provenance of this example is unknown. It was purchased in 1916 to furnish the Frick's Fragonard Room, where it stands today. In 1916, the marble top was replaced and the depth of the mantel increased to accommodate the display of the bust of the Countess of Cayla by Jean-Antoine Houdon.

Tripod Table

French, Paris, ca. 1785
Gilt bronze, lapis lazuli, iron, and oak
H. 28¼ in. (71.8 cm), diam. 16¼ in. (41.3 cm)
Henry Clay Frick Bequest (1915.5.60)

Unique in its design and production, this small
table exemplifies the passion in the second half of
the eighteenth century for rare, hard stones
mounted with exquisite gilt bronzes. The top is
made of a slate disk veneered with lapis-lazuli
marquetry imported from Afghanistan. It was
almost certainly cut and polished in Paris into the
elaborate pattern of overlaying six-pointed stars. A
wealthy and enterprising *marchand-mercier*, most
likely Dominique Daguerre, commissioned a
gilt-bronze maker to produce the frame and
support with three smiling caryatids whose
braided tresses meet at the belt of a long, fringed
tunic drawn in at the waist. Merchants like
Daguerre played a crucial role in producing the
most luxurious and expensive furniture of
eighteenth-century France.

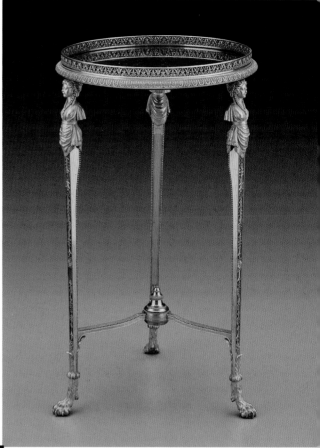

Gilt Bronzes

Pair of Andirons

French, ca. 1710
Gilt bronze
1918.6.01: 15⅝ × 11¼ × 9 in. (39.7 × 28.6 × 22.9 cm)
1918.6.02: 15¼ × 11¼ × 9 in. (38.7 × 28.6 × 22.9 cm)
Henry Clay Frick Bequest (1918.6.01–02)

Designed and used as the front of an andiron (the metal support that holds burning wood), these two pieces are works of art in their own right. The sculptural groups represent famous abductions in which Zeus, king of the gods, assumes the form of an eagle. The andiron on the right depicts the god taking the nymph Aegina, and the companion piece shows him carrying off the beautiful Greek youth Ganymede. These andirons may have furnished the Château de Lunéville in Lorraine in northeastern France. An identical group with Aegina appears on the top of a clock made in 1713 for Élisabeth-Charlotte d'Orléans, Duchess of Lorraine (now in a private collection).

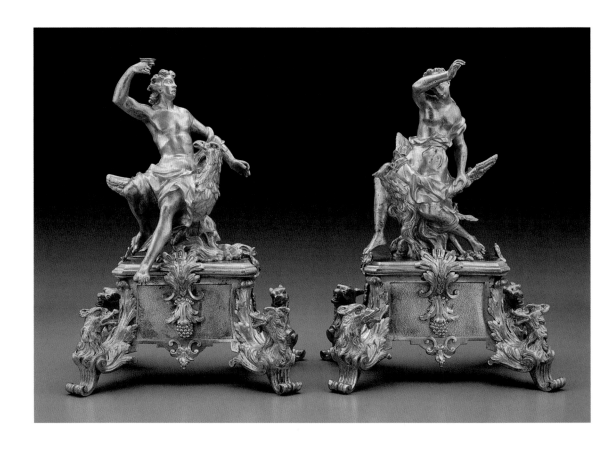

Pair of Mounted Covered Jars

Chinese porcelain, first half of the eighteenth century

French gilt-bronze mounts, 1745–49

Hard-paste porcelain and gilt bronze

15.8.41: 17⅞ × 18⅝ × 10¹¹⁄₁₆ in. (45.4 × 47.3 × 27.1 cm)

15.8.42: 18⁷⁄₁₆ × 18⅝ × 10⅝ in. (47 × 47.3 × 27 cm)

Henry Clay Frick Bequest (1915.8.41–42)

By the late 1740s, trade with China, which brought large quantities of porcelain wares to Europe, had been ongoing for centuries. These two jars reached France soon after they were made in China in the first half of the eighteenth century. Such large monochrome porcelains were especially rare and costly but did not quench the French elite's perpetual thirst for novelty. Innovative *marchands-merciers* often enriched these already lavish objects with elaborate gilt-bronze mounts. Here they feature bulrushes, sea shells, branches of coral, marine rocks, and pearls, combined with abstract scroll motifs in the irrational scale and asymmetric design distinctive of the Rococo, a fanciful style that emerged in Paris in the 1730s and remained in fashion until the 1760s.

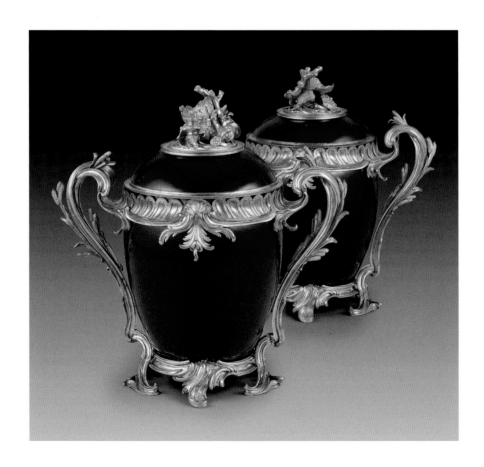

Pair of Mounted Vases

Chinese porcelain, first half of the eighteenth century
French gilt-bronze mounts, ca. 1755–60
Hard-paste porcelain and gilt bronze
18⅛ × 14¼ × 8½ in. (46 × 36.2 × 21.6 cm)
Henry Clay Frick Bequest (1915.8.43–44)

The French gilt-bronze mounts were almost certainly designed specially for the base and handles of these Chinese porcelain vases and not adapted from a pre-existing repertoire of decorative elements, as was often the case. The heavy asymmetrical scrolls are related to work done around 1755–60 by Jean-Claude Duplessis, an Italian sculptor, designer, goldsmith, ceramics modeler, and bronze maker working in France. Duplessis served as artistic director of the Vincennes-Sèvres Porcelain Manufactory from 1748 until his death in 1774 and became *orfèvre du roi* (royal goldsmith) in 1758. He was also directly involved in creating bronze mounts for Chinese porcelain for Lazare Duvaux, the most prominent *marchand-mercier* in Paris in the 1740s and 1750s.

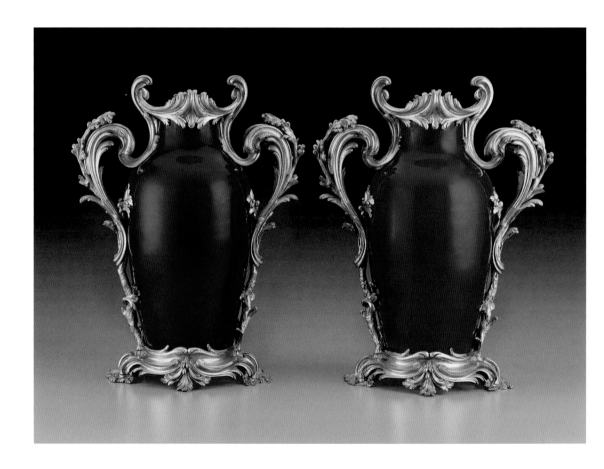

Pair of Mounted Covered Vases

Chinese porcelain, mid-eighteenth century

French gilt-bronze mounts, ca. 1770

Hard-paste porcelain and gilt bronze

Each, 18¼ × 10½ × 7⅛ in. (46.3 × 26.7 × 18.8 cm)

Henry Clay Frick Bequest (1918.8.45–46)

Each of these vases was originally the lower section of a beaker or *tsun*-shaped vase that was severed below its bulging central section. The original piece was cut inside the foot rim to make a new opening, which is now the top of the vase. The lids originally belonged to *kuan*-shaped jars that were cut, altered, and also probably inverted to suit a new purpose. The gilt-bronze mounts are attributed to the Parisian bronze caster Jean Godille, who is mentioned in the 1773 *Almanach du Dauphin* as "famous for his porcelain and other precious mounted vases."

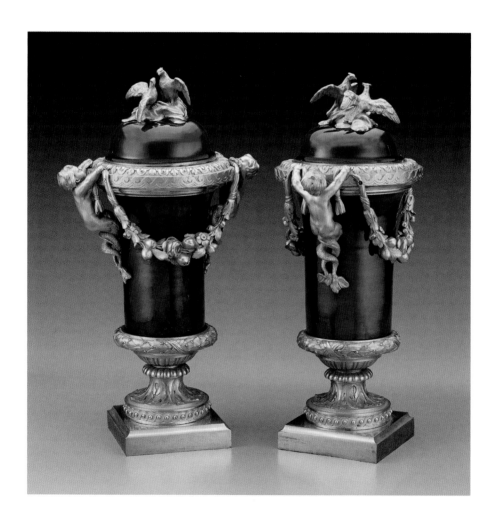

Candelabrum Vase (one of a pair)

French, Paris, ca. 1785
Gilt and patinated bronze, lapis lazuli and marble
Each, 45½ × 19¼ in. (115.6 × 48.9 cm)
Henry Clay Frick Bequest (1915.6.09–10)

These large candelabra feature three patinated-
bronze figurines representing female musicians
seated on the base. One figure leans forward
blowing a pair of pipes (see detail), another beats
a raised tambourine, and the third claps a pair of
castanets. The bronzes borrow a decorative
vocabulary commonly found in other pieces of the
period, including goat heads and swags of
grapevines and flowers. The candle sockets are
concealed in the outermost roses of the luxuriant
bouquets that also include carnations and poppies
amid abundant foliage.

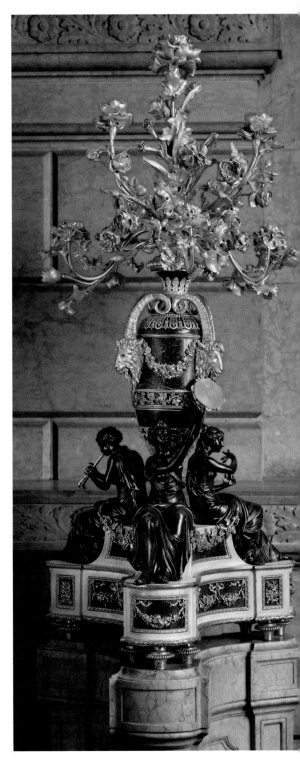

Andiron (one of a pair)

French, Paris, 1785–90
Gilt bronze
Each, 19⅞ × 20 × 7½ in. (50.5 × 50.8 × 19.1 cm)
Henry Clay Frick Bequest (1916.6.03–04)

The celebrated Parisian *marchand-mercier* Darnault Frères created the model for these andirons, which features a perfume burner, supported by three *pieds de biche* (deer legs), and is ornamented with three goat heads and a long garland of flowers and fruits. In 1785, Darnault Frères sold a pair to Madame Adélaïde, one of Louis XVI's aunts, for her bedroom at the Château de Bellevue. Before the French Revolution, this had become a successful model; several similar andirons with only slight variations have survived today in public and private collections in Europe and the United States. The early provenance of this example is unknown.

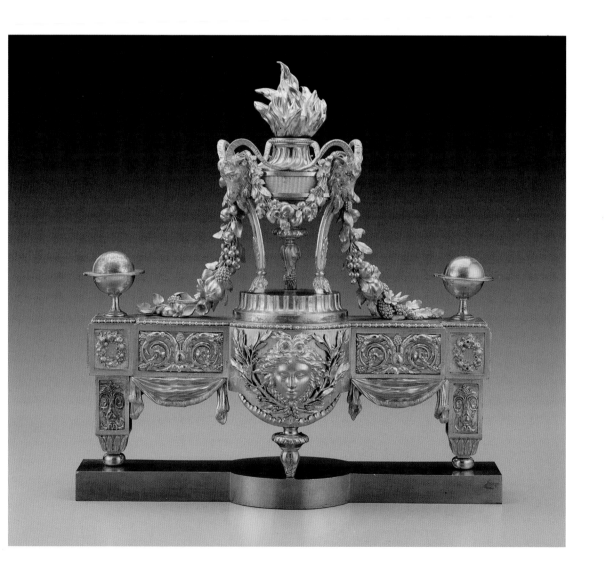

European
Ceramics

Ewer

French, probably Saint-Porchaire,
mid-sixteenth century
Glazed earthenware
9 × 4½ × 3¼ in. (23 × 11.5 × 8.3 cm)
Henry Clay Frick Bequest (1918.9.01)

This ewer was probably made in the small town of
Saint-Porchaire in southwestern France, a region
rich in kaolin, the white clay used to make such
elaborately decorated wares. Only about seventy
authentic pieces of the so-called Saint-Porchaire
ware are known today, and their technical and
ornamental similarities suggest a rather small
production concentrated in the hands of a few
craftsmen, perhaps a single potter, over a period of
less than twenty years between 1540 and 1560.
Courtly objects that were difficult and expensive to
produce and far too fragile to be used daily, these
ceramics were surely linked to the royal court
despite the distance from the center of their
production to Paris and Fontainebleau.

Dish

WORKSHOP OF ORAZIO FONTANA

Italian, Urbino, ca. 1565–75

Tin-glazed earthenware

H. 2⅛ in. (5.4 cm), diam. 16¾ in. (42.6 cm)

Gift of Dianne Dwyer Modestini in memory of
Mario Modestini, 2008 (2008.17.01)

Marcantonio Raimondi after Raphael, *The Judgment of Paris*,
1517–20. Engraving, 11½ × 17¼ in. (29.5 × 43.8 cm). The British
Museum (H,2.24). © Trustees of The British Museum

Italian Renaissance maiolica pieces are remarkable for their rich and colorful decoration. The center of this large dish illustrates a narrative scene, or *istoriato*, depicting the Judgment of Paris, one of the most famous Greek myths. At the marriage of Peleus and Thetis, Eris, the goddess of discord, arrives with a golden apple inscribed "for the fairest." Aphrodite, Hera, and Athena all claim the apple and ask Zeus to judge which of them is fairest. Reluctant to declare a winner himself, Zeus commands Paris, son of Priam, King of Troy, to judge their case. The scene, which depicts the moment when Paris presents the golden apple to Aphrodite, is based on an engraving of around 1517–20 made by Marcantonio Raimondi after a drawing by Raphael. The figures are surrounded by colorful grotesques delicately painted on a white ground, a specialty of the renowned workshop of Orazio Fontana in Urbino, to which the best pieces, including this one, are usually attributed.

Great Bustard

MEISSEN PORCELAIN MANUFACTORY
MODELED BY JOHANN GOTTLIEB KIRCHNER
German, 1732
Hard-paste porcelain
33 × 17 × 11¼ in. (83.8 × 43.2 × 28.6 cm)
Gift of Henry H. Arnhold, 2013 (2013.9.01)

One of the most ambitious projects undertaken at the Meissen Porcelain Manufactory was a porcelain menagerie of life-size animals and birds conceived as interior decoration for the Japanese Palace, a small pleasure palace near Dresden acquired by August II, Elector of Saxony and King of Poland, to display his vast collection of porcelain. Several hundred animals and birds were requested, but fewer than three hundred were successfully fired before the project was abandoned. The *Great Bustard* was designed by Johann Gottlieb Kirchner, the director of the modeling studio at Meissen in the early 1730s. With its head gracefully bent back over its wing, the bird is supported by a tree trunk covered with oak branches, leaves, and acorns. To mold and fire a figure of this size was a technical tour de force, and most of the sculptures have a number of firing cracks produced in the kiln, as does this one. The animals and birds were originally decorated with oil paints. These were later removed from most of the sculptures, including the *Great Bustard*.

Pair of Vases Duplessis "à Enfants"

VINCENNES PORCELAIN MANUFACTORY
French, 1753
Soft-paste porcelain, with later addition of gilt-bronze
mounts
1918.9.02: 8⅜ × 5¾ × 5¾ in. (21.2 × 14.6 × 14.6 cm)
1918.9.03: 8⅜ × 5⅞ × 5⅞ in. (21.2 × 14.9 × 14.9 cm)
Henry Clay Frick Bequest (1918.9.02–03)

First established in Vincennes, the French Royal
Porcelain Manufactory moved in 1756 to the town
of Sèvres, where it became, under Louis XV's
patronage, the most important soft-paste porcelain
factory in Europe. Madame de Pompadour,
the king's mistress, took a special interest, and
with her support, the factory assembled a
remarkable team of artists and craftsmen.
Among them was the goldsmith, sculptor, and
designer Jean-Claude Duplessis, who produced
highly original designs, including the form of
these vases. They were sometimes produced
with chubby little children in relief, as seen here.
Symbolic of the four seasons, these figures are
almost certainly modeled after drawings by
François Boucher, another of Madame de
Pompadour's protégés, who provided models
for the porcelain manufactory.

Potpourri Vase "à Vaisseau"

SÈVRES PORCELAIN MANUFACTORY
French, ca. 1759
Soft-paste porcelain, with later addition of
a gilt-bronze base
17½ × 14⅞ × 7½ in. (44.5 × 37.8 × 19 cm)
Henry Clay Frick Bequest (1916.9.07)

The highly original design for this potpourri vase *à vaisseau* (in the form of a ship) was created in 1757 by the Sèvres Porcelain Manufactory's artistic director, Jean-Claude Duplessis. The present example can be dated to about 1759, the year that Madame de Pompadour purchased her first potpourri ship. The early history of the Frick piece is unknown, but it certainly belonged to a wealthy aristocrat or financier, in whose home the vase would have held a mixture of fragrant dried flowers and spices to scent the air. The painters and gilders responsible for its decoration juxtaposed grounds of apple green and dark blue, the latter enriched with gold in a *caillouté* (pebble-like) pattern. The colorful exotic birds on the front and back reserves were painted by Louis-Denis Armand *l'aîné*, a prominent artist active at the factory between 1745 and 1788, who specialized in birds and landscapes. He also painted the birds on the two vases *à oreilles* on the following page. Gold, the use of which was an exclusive privilege of the Sèvres Porcelain Manufactory, is generously applied along the contours of the piece to emphasize its bold and recognizable shape.

Two Vases "à Oreilles"

SÈVRES PORCELAIN MANUFACTORY
French, ca. 1759
Soft-paste porcelain, with later addition of
gilt-bronze bases
Each, h. 12½ in. (31.8 cm), diam. 6⅝ in. (16.8 cm)
Henry Clay Frick Bequest (1916.9.08–09)

Probably designed by Jean-Claude Duplessis, vases of this type are called *à oreilles* (with ears) because the foliar scrolls at the neck loop back to the shoulder to form ear-like handles. One of the most successful vase forms produced by the celebrated Sèvres Porcelain Manufactory, vases *à oreilles* were made in five sizes, ranging from about four-and-a-half to fifteen inches. These were made en suite with the previous potpourri vase *à vaisseau* (p. 120) and were intended to be displayed together on a mantel or piece of furniture.

Three Potpourri Vases

SÈVRES PORCELAIN MANUFACTORY
French, ca. 1762
Soft-paste porcelain, with later addition of
gilt-bronze bases
1918.9.10: 14³⁄₁₆ × 8½ × 7⅛ in. (36 × 21.5 × 18 cm)
1918.9.11–12: 11 × 6¾ × 5¼ in. (28 × 17 × 13.3 cm)
Henry Clay Frick Bequest (1918.9.10–12)

The Sèvres Porcelain Manufactory called these pear-shaped vases with branches of myrtle and scrolls at the side either potpourri *feuilles de mirte* or *à feuillages*. The model was inspired by metalwork and created by silversmith Jean-Claude Duplessis. This garniture is composed of one vase of the first size and two smaller vases of the second size. All three vases are decorated on the front with a Flemish peasant scene in rich polychrome and on the back with a landscape bathed in soft light. These decorative scenes derive in part from engravings made after paintings by David Teniers the Younger and François Boucher.

Tea Service (seven of eleven pieces)

SÈVRES PORCELAIN MANUFACTORY

French, 1767

Soft-paste porcelain

Teapot: 5½ × 7 3/16 × 4⅛ in. (14 × 18.3 × 10.5 cm)

Sugar bowl: h. 4¾ in. (12.1 cm), diam. 3⅞ in. (9.8 cm)

Cups: 2⅜ × 3 11/16 × 2⅞ in. (6 × 9.3 × 7.2 cm)

Saucers: h. 1¼ in. (3.2 cm), diam. 5 7/16 in. (13.8 cm)

Milk jug: 4⅝ × 5 × 3½ in. (11.8 × 12.7 × 8.8 cm)

Henry Clay Frick Bequest (1918.9.21–31)

This tea service consists of a teapot, a sugar bowl, a milk jug, four cups, and four saucers. All the pieces are similarly decorated with polychrome birds in landscape settings in reserved panels surrounded by a turquoise ground spangled throughout with gold dots. The decorative scenes are the work of Antoine-Joseph Chappuis, who specialized in painting birds and flowers and was active at the factory between 1756 and 1787. Chappuis generally depicted his birds in or below a tree with a gnarled trunk, as on these pieces. He used a rich and delicate palette to create subtle variety to the birds' plumage and added a lighter touch in the birds' dark pupils to create their penetrating glances. It appears that some of these birds were copied from two of the seven volumes of *The Natural History of Birds* and *Gleanings of the Natural History,* by the English naturalist George Edwards, and introduced to Sèvres in 1765 by the Duke of Richmond, who gave the manufactory his personal copies of this collection of models.

Vase Japon

SÈVRES PORCELAIN MANUFACTORY
French, 1774
Hard-paste porcelain with silver-gilt mount
H. 10½ in. (27 cm), diam. 8 in. (20.3 cm)
Purchase in honor of Anne L. Poulet, 2011 (2011.9.01)

Despite its name, the *vase japon* is an interpretation of a Chinese bronze Yu (or Hu) vase from the Han Dynasty (206 B.C.–220 A.D.). Its design and decoration derive from a woodblock print published in a forty-volume catalogue of the vast Chinese imperial collections compiled between 1749 and 1751 at the behest of the Qianlong emperor. Around 1767, a copy of this catalogue was sent to Henri Bertin, who at the time was France's secretary of state and *commissaire du roi* at the Sèvres factory. The *vase japon* was made in 1774 along with two other vases of the same size, shape, and decoration. Each bears the mark of the gilder-painter Jean-Armand Fallot, who was employed by Sèvres between 1764 and 1790. Of the three, however, only this example is adorned with a silver-gilt handle and chain, which, like its shape and surface pattern, are directly inspired by the Chinese model. The mounts bear the mark of Charles Ouizille, who, in 1784, became the official jeweler of Louis XVI.

Yu Vase. Reproduced in *Qin ding Xi qing gu jian* [catalogue of the Chinese imperial collections], ca. 1755. Rare Books Collection, Special & Area Studies Collections George A. Smathers Libraries, University of Florida. Image courtesy University of Florida Digital Collections

Water Jug and Basin

SÈVRES PORCELAIN MANUFACTORY
French, 1781
Soft-paste porcelain with gilt metal
Jug: 8¼ × 5⅝ × 5⅛ in. (21 × 14.2 × 13 cm)
Basin: 11⁷⁄₁₆ × 9⅞ × 3⅛ in. (29 × 25 × 8 cm)
Gift of Miss Helen Clay Frick, 1934 (1934.9.44–45)

The Sèvres Porcelain Manufactory produced matching jugs and basins of different shapes and sizes beginning in the early 1750s. The smallest jugs were used to serve milk, and larger ones were for water. These were intended for use during either the morning ritual of the toilette, usually on display on the dressing table, or in the *garde-robe* as the precursors of the plumbed-in hand basin. Jean-Louis Morin (act. 1754–87) painted the marine scenes, then very fashionable at Sèvres. Morin began his career at Vincennes, where he painted cupids and infants after François Boucher before specializing in military scenes and, in the 1780s, coastal views similar to the ones on these pieces.

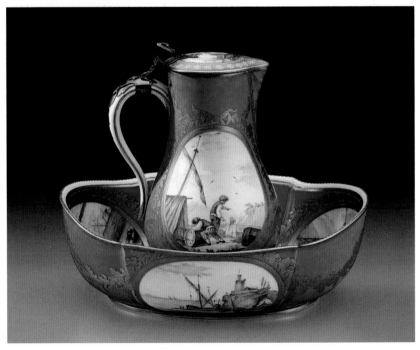

Chinese
Porcelain

Stem Bowl

Chinese, probably Jingdezhen, Jiangxi province,
probably late sixteenth or early seventeenth century
Hard-paste porcelain with underglaze blue
H. 4 in. (10.2 cm), diam. 6 in. (15.2 cm)
Bequest of Childs Frick in memory of Frances Dixon
Frick, 1965 (1965.8.71)

With cobalt blue imported from Persia, porcelain in
the celebrated blue-and-white style was first
produced in China in the fourteenth century during
the Yuan dynasty (1271–1368) and remained
fashionable for centuries. In the center of this bowl,
a man in profile sits on the ground. In the back-
ground are a cliff, a pine tree, and a moon in the
sky. The outside of the bowl depicts scholars
gathered near a pavilion in a garden, some reading
books, some admiring a scroll of calligraphy, and
two playing Wei-ch'i (or Go, as it is known in Japan
and the West), an ancient board game.

Small Covered Jar (one of a pair)

Chinese, probably Jingdezhen, Jiangxi province,
probably late seventeenth or early eighteenth century
Hard-paste porcelain with underglaze blue
H. 3⅜ in. (8.5 cm)
Bequest of Childs Frick in memory of Frances Dixon
Frick, 1965 (1965.8.164–65)

Each of these two small jars is decorated with
three clawed dragons chasing pearls in flames.
Dragons were typically found exclusively on
imperial commissions but on occasion may have
been used to decorate non-imperial pieces such as
these. As indicated by the mark painted on the
bottoms of the jars, they were produced during the
reign of Kangxi (1662–1722), an attribution further
confirmed by the grayish color of the glaze and the
typical Kangxi representation of dragons in
three-quarter profile. In late seventeenth and
early eighteenth-century China, such small
objects—reduced versions of larger pieces—were
often displayed on a Chinese scholar's desk.

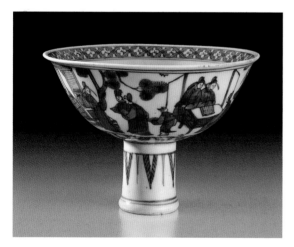

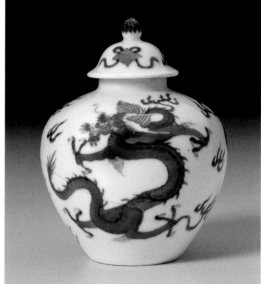

Bowl

Chinese, probably Jingdezhen, Jiangxi province,
probably seventeenth century
Hard-paste porcelain with underglaze blue
H. 2⅝ in. (6.7 cm), diam. 5⅝ in. (14.5 cm)
Bequest of Childs Frick in memory of Frances Dixon
Frick, 1965 (1965.8.69)

This small, perfectly round bowl supported by a circular foot exemplifies the lightness and pure white color for which Chinese porcelain was so admired in the West. The bowl is decorated with a garland of stylized lilies and leaves, in which a finely brushed outline in dark blue is filled with a wash of lighter blue. Its shape and style of decoration were developed in one of the finest periods for the production of blue-and-white porcelain, the reign of Chenghua (1465–87), but the rendering of the design lacks the spontaneity and subtlety of the fifteenth-century pieces. Moreover, under the foot is the six-character mark of the late Ming reign of Wanli (1573–1620), which began some eighty-six years after the reign of Chenghua. Excellent copies of such bowls were made in the late seventeenth century during the reign of the Emperor Kangxi (1662–1722). Potters usually signed them with Chenghua marks to emphasize their resemblance to the earlier models, but it is possible that one of them chose to apply a mark from the Wanli reign.

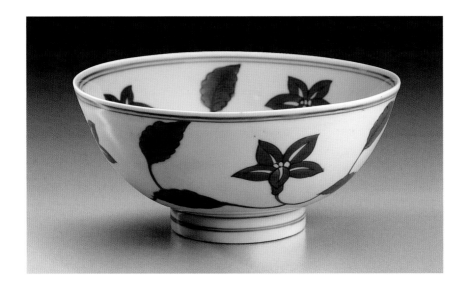

Dish

Chinese, probably Jingdezhen, Jiangxi province,
seventeenth century or early eighteenth century
Hard-paste porcelain with underglaze blue
H. 1¼ in. (3.2 cm), diam. 10⅛ in. (25.7 cm)
Bequest of Childs Frick in memory of Frances Dixon
Frick, 1965 (1965.8.197)

In the center of this dish with rich cobalt-blue
decoration, three ladies enter the terrace of a
house surrounded by a garden with a banana tree,
a plum tree, and two bamboo shoots. On the rim,
four vignettes separated by elaborate geometric
patterns represent scholars engaged in various
activities. The six-character mark of the Kangxi
reign (1662–1722) is painted on the base. In the
early eighteenth century, a set of thirty dishes
similarly decorated, but smaller in size, reached
Dresden as part of the vast and prestigious
collection of porcelain assembled by August II
(1670–1733), Elector of Saxony and King of Poland,
better known as Augustus the Strong.

Small Vase

Chinese, probably Jingdezhen, Jiangxi province,
eighteenth century
Porcelain with underglaze blue
H. 4⅛ in. (10.5 cm), diam. 3⅜ in. (8.6 cm)
Bequest of Childs Frick in memory of Frances Dixon
Frick, 1965 (1965.8.149)

This small vase in the shape of a fruit, probably a
pomegranate, is decorated with sprays of peaches
and the unusual fruit known as Buddha's hand
citron. The clay used is of an exceptionally fine
type known as "soft paste," which was developed
in the early part of the eighteenth century. A much
more expensive material than the hard-paste
usually used in Chinese porcelain, it was probably
reserved for small and very choice objects
displayed on the scholar's desk.

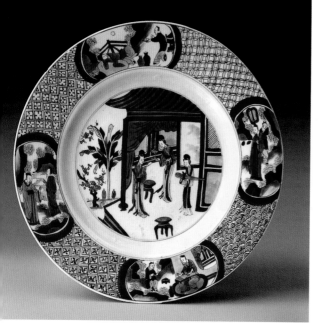

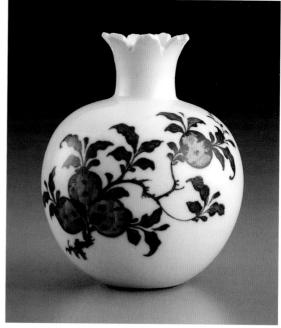

Covered Jars (two of four)

Chinese, probably Jingdezhen, Jiangxi province,
eighteenth century
Hard-paste porcelain with underglaze blue
Each, h. 10⅛ in. (25.7 cm), diam. 8½ in. (21.6 cm)
Henry Clay Frick Bequest (1915.8.01–04)

Beginning in the early eighteenth century, jars with plum-blossom decoration were made in China for export to Europe, where they were sought by early collectors of Chinese porcelain, among them, Augustus the Strong. The art dealer Henry Duveen acquired these four jars in the late nineteenth century: the first in 1886, in England, at the Duke of Marlborough's celebrated Blenheim Palace sale; the second in 1891, in New York, at the sale of the important collection formed by General Brayton Ives; the third in Paris from the art dealer Siegfried Bing; and the last in New York at the American Art Gallery. In the late 1890s, Henry Duveen sold the set to the preeminent American collector James Garland but bought it back in 1902 following Garland's death (along with the rest of the Garland collection of Chinese porcelain). Duveen sold the set immediately to J. Pierpont Morgan but purchased it back after Morgan's death in 1913. With his nephew, legendary art dealer Joseph Duveen, he sold it a final time to Henry Clay Frick in 1915 for the high price of $80,000.

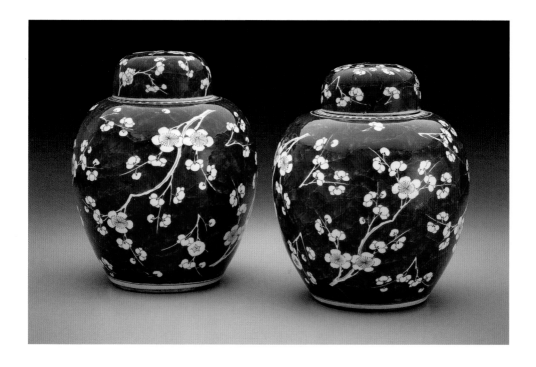

Two Figures of Ladies on Stands

Chinese, probably Jingdezhen, Jiangxi province,
early eighteenth century
Hard-paste porcelain with polychrome overglaze
Each, 38 × 10¼ × 10¼ in. (96.5 × 26 × 26 cm)
Henry Clay Frick Bequest (1918.8.39–40)

A particularly fruitful and innovative period of
production, the late seventeenth and early
eighteenth centuries saw the development of
new techniques and styles of ornamentation.
One of the most important contributions was the
invention of overglaze enamel palettes, known
as *famille vert* because they are dominated by
translucent green glazes. These two porcelain
figures of elegant ladies on stands are decorated
with a colorful mix of green, red, yellow, auber-
gine, and blue glazes in a pattern of naturalistic
motifs including chrysanthemums, rose blossoms,
and flying storks combined with abstract elements
like the large *wan*—a swastika-shaped Buddhist
symbol for good fortune—that is repeated on the
porcelain bases. The women represent ideal
female beauty, as defined by the seventeenth-
century writer and aesthetician Li Yu (1611–1680):
egg-shaped rather than round faces, eyebrows
lightly curved like the leaves of a willow tree, lips
resembling cherries, and slim, supple, curved
bodies also resembling willow trees. Their deli-
cate hands seem to be offering a fruit or a flower,
in China the sign of a good wish extended from a
woman to a man. These two figural ceramics were
probably made for export to the West; however,
their large size made them particularly fragile to
ship, and only a few ever reached Europe.

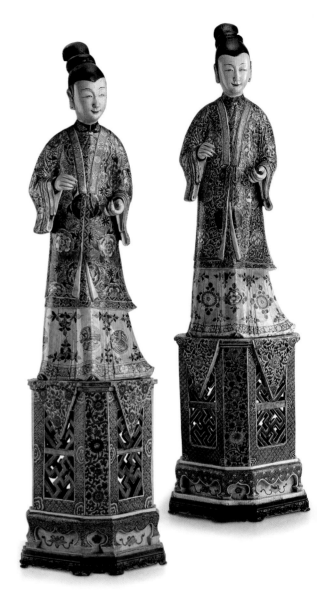

Two Covered Jars

Chinese, probably Jingdezhen, Jiangxi province,
eighteenth century
Hard-paste porcelain with polychrome overglaze
Each, h. 25 in. (63.5 cm), diam. 14 in. (35.6 cm)
Henry Clay Frick Bequest (1915.8.57–58)

Painted with a deep and rich pink ground (*famille rose*), these jars feature polychrome chrysanthemums and vignettes in reserve. The main panels on both sides of each jar depict an elderly scholar reading a book to a young boy. Flowers, birds, and domestic fowl appear in fan- and ribbon-shaped panels. These decorative motifs derive from pattern books commonly used in eighteenth-century Chinese porcelain factories. *Famille rose* appeared in the 1730s as a result of the importation from Europe of purple of Cassius (a pigment obtained from gold chloride).

Vase

Chinese, probably Jingdezhen, Jiangxi province,
probably nineteenth century
Hard-paste porcelain with polychrome overglaze
H. 27 in. (68.6 cm), diam. 11 in. (27.9 cm)
Henry Clay Frick Bequest (1915.8.24)

Small black-ground wares were produced in China during the reign of Emperor Kangxi (1662–1722). However, large vases, such as this one, were produced in the nineteenth century in China or in Europe to satisfy the taste of British and American collectors. Henry Clay Frick purchased twenty-three of them, often at a high price, from the art dealers Henry and Joseph Duveen. They all came from the collection of the great American financier J. Pierpont Morgan.

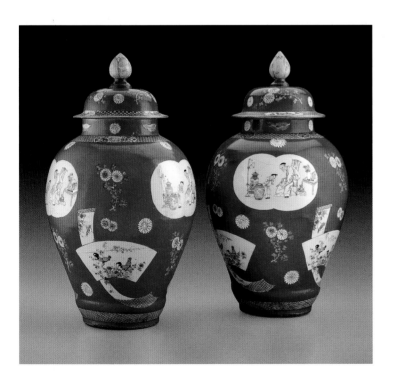

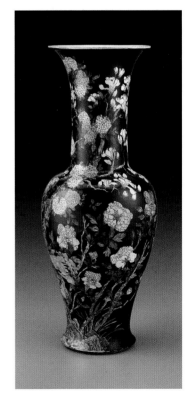

Silver

Écuelle

PAUL DE LAMERIE
English, London, 1739–40
Silver gilt
6¾ × 9¾ × 6¹⁄₁₆ in. (17.2 × 24.8 × 15.4 cm)
Henry Clay Frick Bequest (1916.7.02)

Decorated with vegetables, herbs, and a trussed red grouse on the finial, this two-handled shallow bowl, or *écuelle*, was probably intended for porridge, which is defined in a 1728 English dictionary as "a liquid Food of Herbes, Flesh, &c." French in origin, *écuelles* are rare in English silver. This example was made in London by Paul de Lamerie, son of a French émigré and one of the greatest eighteenth-century English silversmiths. In de Lamerie's obituary in the *London Evening Post* of August 6, 1751, he is described as "particularly famous in making fine ornamental Plate" and having been "very instrumental in bringing that Branch of Trade to the perfection it is now in."

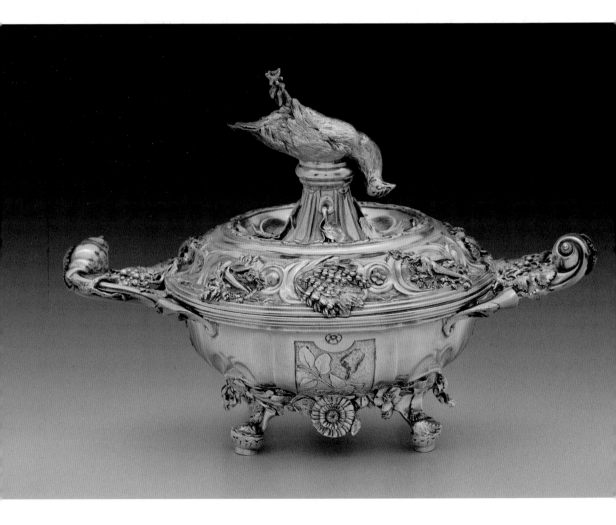

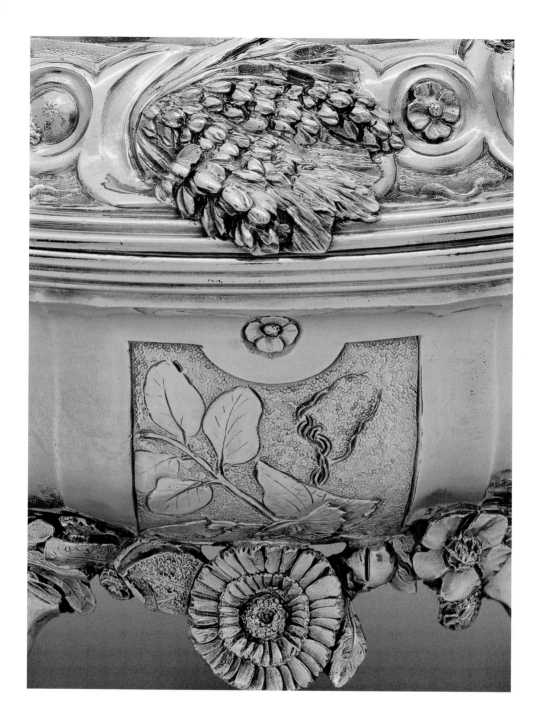

Wine Cooler (one of four)

WILLIAM PITTS

English, London, 1802–04

Silver gilt

Each, h. 9¾ in. (24.8 cm), diam. 9¾ in. (24.8 cm)

Henry Clay Frick Bequest (1915.7.03–06)

Beginning in the late seventeenth century, English silversmiths produced vessels for chilling bottled wine in ice or ice water before serving. Their function, form, and decoration were derived from French customs and designs. These smaller coolers hold individual bottles and have a removable liner and a separate collar. They bear the arms and crest of the Ashburnham family with the earl's coronet and the motto LE ROY ET L'ESTAT (The King and the State) and were probably made for John, second Earl of Ashburnham or his son, George.

Wine Cooler (one of two)

BENJAMIN AND JAMES SMITH
English, London, 1811–12
Silver gilt
Each, h. 10¼ in. (26 cm), diam. 9¼ in. (23.5 cm)
Henry Clay Frick Bequest (1915.7.07–08)

These two coolers are decorated with ornaments
that allude to wine: a band of spiraling vine
tendrils, grapes, and masks of Bacchus, the Roman
god of wine and revelry. In ancient mythology,
Bacchus could take the shape of a snake, formed
here in the coolers' handles. These wine coolers
are engraved with the arms and crest of Joseph
Burn—formerly Joseph Teasdale, of Lincoln's Inn
Square, Middlesex, and of Orton in the County of
Westmoreland—and of his wife, Eulalia Vila, from
Barcelona, Spain.

Textiles

Carpet

Persian, Herat, second half of the sixteenth century
Cotton (warp and weft), wool (weft), and Senna (pile)
21 ft. 10½ in. × 9 ft. 6½ in. (667 × 291 cm)
Henry Clay Frick Bequest (1916.10.01)

The elaborate floral design of this carpet is
characteristic of Persian textiles attributed to the
looms of Herat, the capital of the eastern Iranian
region of Khurasa during the sixteenth century
and today a city in Afghanistan. Persian artists
transformed the lotus and peony blossoms of
China into stylized ornaments known as pal-
mettes, which they created in many varieties.
Some are composite, incorporating two or even
three motifs, often in the form of large leaves with
serrated outlines enclosing either a peony
palmette or a stylized pomegranate (see detail).
Here, they form a symmetrical pattern made in
thirteen colors over a burgundy red field sur-
rounded by an arabesque and floral border. Herat
carpets were prized in the West as early as the
seventeenth century, as evidenced by their
representation in paintings by celebrated artists,
including Velázquez, Vermeer, and Van Dyck.

Carpet

North India, ca. 1630
Silk (warp and weft) and pashmina (pile)
7 ft. 7 in. × 6 ft. 6½ in. (231 × 199 cm)
Henry Clay Frick Bequest (1916.10.07)

Long imported from Persia, carpets began to be woven in India in the second half of the sixteenth century under the patronage of the Mughal dynasty. This fragment of what was once a much larger carpet reflects the high quality reached during the reign of the Mughal emperor Shah Jahan (1628–58), who is best known for building the Taj Mahal. With its naturalistic depiction of flowers and trees, it epitomizes the distinctive style of the imperial court. On a rich red ground, a row of alternating varieties of green and flowering trees—including cypresses, various kinds of broad-leaf trees, and yellow peachlike and pink plumlike trees—appear at center. The large border is woven with stylized flowers, leaves, buds, and palmettes. Though the design is symmetric and repetitive, none of the motifs are entirely identical, producing an animated composition. The delicate polychromatic shading and refined foliage, which find parallels in Indian miniature paintings, were achieved through the use of expensive materials, notably imported silk (for the warps and wefts), costly dyes exclusively available in India, and the most rare natural material used for carpet weaving: the very fine hair of Himalayan goats, known in the West as cashmere and, more recently, pashmina. The extraordinary quality of this fragment and the size of the carpet to which it belongs leave no doubt that the carpet was made in one of the official imperial workshops for a member of the Mughal imperial family or someone very close to it.

145

Carpet

North Indian, ca. 1650
Silk (warp and weft) and pashmina (pile)
6 ft. 5¼ in. × 3 ft. 11 in. (196 × 119 cm)
Henry Clay Frick Bequest (1916.10.08)

Due to their constant use in palaces and mosques
for hundreds of years, only about five hundred
Mughal carpets survive today, and these are often in
poor condition. Designed and woven in the middle
of the seventeenth century, toward the end of the
reign of Shah Jahan, this rare fragment depicts
seven varieties of plants arranged with no apparent
symmetry but not overlapping, in a seemingly
spontaneous composition. Although such floral
designs are often found on Indian carpets, the
monumental scale of each principal flower on this
fragment is unique. No other fragments of this
carpet are known to have survived.

147

Arrival of the Shepherdesses at the Wedding of Camacho; Sancho Departs for the Isle of Barataria

WORKSHOP OF PETER VAN DEN HECKE AFTER
PHILIPPE DE HONDT
Flemish, Brussels, ca. 1730–45 (before 1748)
Wool and silk
1965.10.20: 10 ft. 3 in. × 18 ft. 3 in. (313 × 555.2 cm)
1965.10.21: 10 ft. 4 in. × 19 ft. 5 in. (314.6 × 591.2 cm)
Bequest of Childs Frick, 1965 (1965.10.20–21)

Around 1730–40, the Brussels workshop of Peter Van den Hecke produced a series of eight tapestries illustrating Cervantes's *Don Quixote*. Six of them—including these two panels—were inspired by engravings made between 1723 and 1734 after twenty-seven cartoons, or preparatory works, painted by the French painter Charles Coypel to serve as models for tapestries produced at the Gobelins manufactory in Paris. *Arrival of the Shepherdesses at the Wedding of Camacho* depicts the festivities taking place before the arrival of the groom, Camacho, and his bride, Quiteria, at their country wedding. Don Quixote, the armored knight, sits on a rock at right while his companion, Sancho Panza, at left, reclines under a tree enjoying the generous provisions of the host. In *Sancho Departs for the Isle of Barataria*, the composition is organized around Don Quixote embracing Sancho, dressed in a red overcoat and holding a white turban. Rather than faithfully copying Coypel's scenes, the painter who provided cartoons for Van den Hecke borrowed elements from the celebrated engravings and set them into landscapes reminiscent of seventeenth-century northern Dutch paintings. Soon after they were made, these two panels were acquired by the French Royal Collection. In 1749, they were displayed at the Château de Compiègne in the study of the eldest son of King Louis XV, Louis, Dauphin of France.

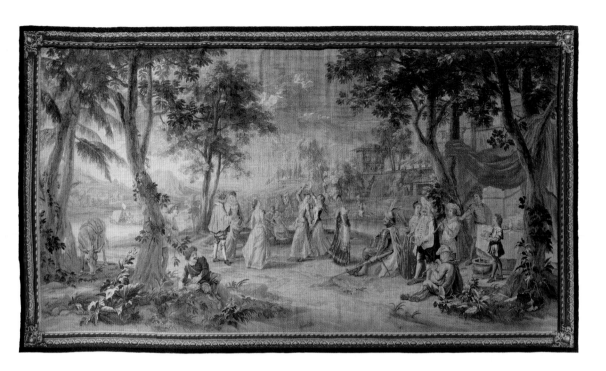

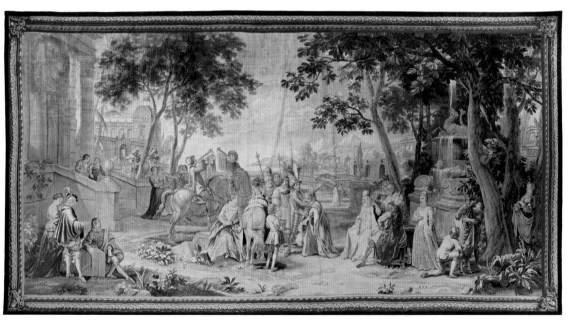